TURNER WATERCOLOURS

TURNER WATERCOLOURS

IN THE CLORE GALLERY

selected and introduced by

ANDREW WILTON

THE TATE GALLERY

cover
'The Burning of the Houses of Parliament'
1834 (233 × 325 mm)

EWART

ISBN 0 946590 66 4 (paper)
ISBN 0 946590 67 2 (cloth)
Published by order of the Trustees 1987
Copyright © 1987 The Tate Gallery All rights reserved
Designed and published by Tate Gallery Publications,
Millbank, London SW1P 4RG
Printed in Great Britain by
Westerham Press, Westerham, Kent

Turner as a Watercolourist

It can be said of few artists that the whole potential of a particular medium is summed up and exemplified in their work. The statement certainly applies to Joseph Mallord William Turner and the medium of watercolour: everything that watercolour has ever been called upon to do, he did; and he was almost singlehandedly responsible not only for the greatest technical developments of the medium, but for bringing those developments to a level of perfection that signalled its most important achievements. Those achievements are among the greatest of the Romantic period, and, as Turner intended they should be, outstanding in the whole history of landscape.

The association between watercolour and landscape has a long history. Since the Middle Ages the medium had been used as a means of applying colour to drawings either because they were intended to embellish manuscript books, or because their subject-matter was more completely rendered with the aid of colour. In the latter case, depictions of scenery – trees, plains, distant hills and clouds – naturally called for a means of expression more fluid than line alone; and the earliest essays in the 'modern' use of watercolour are often studies of landscapes or plants, or, occasionally, of birds whose plumage equally requires the combination of refined detail with an evocation of soft texture. The origins of the medium are reflected in the way the term 'watercolour' is often applied today: as a description of drawings executed not only in pure watercolour but also in the more opaque medium of bodycolour, which incorporates lead white or clay with the main pigment and so achieves the density favoured by medieval and renaissance illuminators. Both watercolour and bodycolour use water as their vehicle; but bodycolour, because of its opacity, does not need to be painted on to a white ground, and adheres satisfactorily to materials other than smooth paper – the vellum of a missal or the chicken-skin of a fan; or indeed the rough sheets of laid paper, the sole type available until the development of wove papers in the late eighteenth century. Bodycolour had something of the density of tempera, and could also attain the brilliance of oil paint. Watercolour itself was less powerful by nature and was at first used rather timidly. Only in the hands of rare masters like Dürer and Van Dyck (who both employed it to paint small-scale landscape studies) was it able to express something of its true capacity for subtlety and fluidity in rendering the forms and atmosphere of nature. More usually it was added rather perfunctorily to outline drawings that were complete in themselves and to which it could contribute little beyond generalised indications of local colour – green for trees, red for buildings, blue for sky.

This convention continued well into the eighteenth century, and although it was brought to a considerable pitch of sophistication in the work of several brilliant artists, it was essentially the system obtaining when Turner was born in 1775. Watercolour was used in England primarily to render more attractive views of particular places that were first stated fully with pencil, pen and ink. A wash of grey was generally added to indicate the tonal contrasts of the design, and only then was local colour introduced. The grey underpainting supplied

darker tones; the white paper itself was reserved for highlights; and the whole design drew its characteristic luminosity from the transparency of the pigments which allowed the whiteness of the paper to illuminate the entire subject. These features gave the medium its special appropriateness to land-scapes showing English country houses in undulating sunny parkland, to panoramas of distant towns with strolling citizens or resting haymakers to enliven their foregrounds.

During Turner's youth a number of artists had brought this kind of topogra-phical watercolour to a degree of perfection which seems to sum up, in many ways, the calm sunny reasonableness and delight in restrained beauty that we particularly associate with the English eighteenth century. As a student and ambitious young professional artist it was Turner's aim to emulate the masters who had achieved this. Already by 1790, when he first sent a watercolour to the Spring Exhibition of the Royal Academy, he could imitate almost exactly the style and subject-matter (even down to the figures) of London's leading architectural topographer, Thomas Malton, under whom he had trained for a short time. The topographical tradition on to which he thus confidently grafted himself at the age of fifteen was to remain a basic and essential inspiration to him throughout his long career. It was largely responsible for forming his attitude to landscape: it taught him to draw architecture with supreme assur-ance and ease; it gave him a lifelong respect for the individuality of particular places and a fascination with the varying character of towns, cities and villages throughout Britain and Europe; and it helped him to see both architecture and landscape as an economic and historical whole, welded together by the human life and activity that is essential to the interpretation of both.

By the time he was twenty, in 1795, Turner had not only made himself master of the topographical conventions; he had emerged quite clearly as the most accomplished topographer alive, with a style entirely his own, more subtle both in conception and technique than that of anyone else, with the possible exception of his almost equally precocious contemporary and fellow Londoner, Thomas Girtin. But while Girtin remained essentially a topographer – albeit an inspired one – for the whole of his short life (he died in 1802), Turner had already by 1795 given signs of wishing to pursue and conquer more ambitious art forms. As early as 1792 he experimented in watercolour with the effect of an oncoming rainstorm, hinting at the achievements of the romantic master of landscape that he was to become. And in the same year he painted a small, unpretentious oil painting – his first, apparently, in that medium. Even more significant, perhaps, was an essay in the 'historical' mode which can also be dated to 1792: a spirited monochrome drawing which illustrates the incident of Don Quixote and the Enchanted Boat (Private collection). The lively, comic figures involved in the incident – to say nothing of the fact that they are taken from a work of European (not English) literature – demonstrate the way his young mind was expanding into new fields, far removed from the topography with which he was establishing his immediate reputation. With such burgeon-ing ambitions it is not surprising that he should have modelled his style at this time on an artist with a continental reputation, the Alsation Philippe Jacques de Loutherbourg, one of the most technically accomplished, various and powerful of the painters then practising in London. Other important influences at this stage were the Swiss Abraham-Louis-Rodolphe Ducros and the great Italian printmaker Giovanni Battista Piranesi, both of whom he probably began to look at in about 1795. His work quickly reflects these influences: the grand scale and strong dense colouring of Ducros, the dramatic chiaroscuro and romantic presentation of classical ruins in the work of Piranesi, can be felt as strong impulses behind the finished watercolours that Turner showed at the Royal Academy exhibitions from 1797 until the end of the decade. And in 1796 he also contributed his first oil-painting to the Academy: a night-piece,

with boats at sea under a cloud-swept moon which again illustrates his new concern for dramatic effects of light and shade.

As far as watercolour was concerned, these new expressive aims required more radical modifications of the traditional procedures. Turner had already abandoned pen outline and, like most of his more advanced contemporaries, applied his local colour direct, dispensing with the grey underpainting of the old practice. He now studied to give his colour the maximum local intensity and overall force, and to make it susceptible of the greatest possible range of variations. When working on a subject destined for public display, and even studies for such a work, he would lay in whole sectors of his paper (often a very large sheet) with warm, rich washes of brown, red, blue or green, analogous to the initial stages of painting in oil; he would overlay these with further washes of darker colour, which he could pierce to reveal those below, or to expose the white of the paper itself. The piercing might be done simply by leaving an area untouched by the brush, but more usually in the finished works it involved the use of a stopping-out process, or a method of removing portions of a wash after it had dried by drawing a brush full of water over the areas to be removed and then blotting them. In addition, he could take away colour with even greater precision by scraping with a knife or with his sharpened thumbnail. He frequently manipulated the paint with his fingers, too. Most of his finished watercolours throughout his life display these techniques in various combinations; as he developed he added to them an ever more sophisticated use of delicate hatching over the broad washes, by which he achieved the minute precision and concentration of the detail which is as remarkable a feature of his watercolours as their mobility and breadth.

Turner's colleagues at the Academy were much impressed by these experiments, which were paralleled by equally important progress in his oil paintings. In 1799 he was elected an Associate of the Academy, and three years later, at the early age of twenty-seven, he became a full Academician. He began to exhibit huge, ambitious canvases in the 'Grand Manner', emulating Poussin, Titian, Claude and Ruysdael; he was much influenced by the teachings of the first President of the Academy, Sir Joshua Reynolds, and by the works of the foremost of eighteenth-century British landscape painters, Richard Wilson. Building on these great examples he quickly established himself as the leading landscape artist of the time; but while his paintings were to remain subjects of astonishment that were generally felt to be inimitable (though he had his followers, of course; at least in the first half of his career), his watercolours, by contrast, which in reality were even more difficult to copy, became the example and model of every serious practitioner in the medium. By 1804 his technical experiments had met with such acclaim that a group of watercolourists in London founded a new academy dedicated specifically to the needs of their revitalised art: the Society of Painters in Water-Colours, later known as the Old Water-Colour Society. In the annual exhibitions of the Society for the next fifty years or more Turner's pre-eminence as a watercolourist was to be seen celebrated in countless acts of homage by dozens of hands. He himself was ineligible for membership, since he was a Royal Academician; but his influence was of paramount importance to all watercolourists of his generation and the next.

Those years of the conception and inauguration of the Water-Colour Society were years in which Turner's own work in the medium reached new heights of grandeur and technical brilliance. He had been inspired to outdo himself by a succession of sketching tours in the late 1790's, first to the moors, lakes and hills of the north of England, and then to the mountains of Wales, which stimulated him to some of the most impressive of his early studies, and confirmed in him that love of mountain scenery which was to take its place alongside the sea as the subject-matter most often associated with him. Later,

in 1801, he visited the Scottish Highlands where, after the impassioned out-bursts provoked by Wales, he was able to reinvest sublime landscape with a classic dignity, deliberately confining himself in a whole series of studies to the chaste medium of pencil on grey ground. As a kind of logical extension of these tours he found himself able, in 1802, to take advantage of the brief Peace of Amiens and travel through France to the Swiss Alps. Here he made notes that build on the lessons of his Scottish journey; they were to become the foun-dations of a sequence of magnificent watercolours (and a few paintings) exhibi-ted either at the Academy or in a gallery which he built and opened for his own private use at his house in Queen Anne Street.

On his way back from Switzerland he stayed in Paris, where he avidly studied the huge collection of masterpieces which Napoleon had assembled in the Louve and elsewhere. The combined stimulus of the art of the Old Masters and the sublime landscape of the Alps provided just what Turner needed to create new works that would be worthy of the great European tradition to which, self-confident as he was, he felt himself to belong. The influence of Poussin and Gaspard, of Claude and Ruysdael, is to be found as much in his works in watercolour as in his oils; a continual striving after grandeur of effect, and an aesthetic permanence over and above the temporary appeal of mere view-making, is characteristic of his art. He was dedicated to proving that landscape painting was an art form as serious as any other; and it could convey the noblest and most passionate ideas, and move us just as the more obviously 'serious' subjects taken from history or mythology could do. For his reason Turner's topographical subjects are often cast into the form of dramas: the human beings who people the landscape are made to enact the tragedy and the comedy of man's relationship with nature, his oppression by storms and floods, his joy in sunshine or the abundance of harvest.

In order to cram this amount of significance into his landscapes, Turner had to evolve, not only a highly flexible and elaborate technical vocabulary but also a huge reference library of effects upon which to draw. What he did was to fill sketchbooks – often, at first, rather large leather-bound ones, but later smaller, pocket-sized books – with drawings made on his travels, and to file these away, carefully labelled, for future reference. Each book had on its spine the names of the principal localities recorded in its pages, or some other form of identifi-cation, and could be taken out and referred to, if need be, twenty or even forty years afterwards in the making of a finished work. The fact that Turner did, on many occasions, thus rely on material gathered much earlier shows clearly that the preoccupations of his youth continued to interest him throughout his life.

Turner did not as a rule make finished works, in any medium, out of doors. It was indeed not the habit of artists at that date to do so, though the romantic practice of making sketches in colour in the open air was gaining ground in the first decade of the nineteenth century: many of the English watercolourists, including Turner, would sometimes make coloured studies on the spot, and they occasionally sketched in oil as well. Turner's great contemporary John Constable produced many oil studies out of doors; but he too generally executed his finished paintings in the studio. At different times in his life Turner used the medium of oil for sketching in the open, and when he did so achieved an immediacy and freshness which places these relatively rare works among the great examples of the genre. He often used watercolour when working in his sketchbooks, but the evidence suggests that even here it was more usual for him to add the colour later, rather than doing so directly in front of the motif. One report tells of Turner saying that 'it would take up too much time to colour in the open air – he could make 15 or 16 pencil sketches to one coloured'; and it seems likely that this reflects his normal procedure, even if he did occasionally deviate from it. The great majority of the drawings in the sketchbooks themselves, therefore, are in pencil alone; but many of the

separate coloured studies that survive were evidently at one time the leaves of sketchbooks. Some of these were dismantled by Turner himself, and some were disbound after his death to facilitate exhibition.

The colour studies vary enormously in type and function. The earliest, emanating from Turner's youthful tours through England and Wales, are partial notes of what he saw, essays in the exact rendering of nature. But by the time of his first continental journey he had evolved a way of studying nature from which all tentativeness had vanished. The notes that he made in his Swiss sketchbooks, for example, are often half-way to being satisfactory works of art in themselves, embodying a subtle transmutation of nature into forms and rhythms that are more pictorial than natural, but combine the aesthetic satisfaction of art with the liberal invention and spontaneity of nature. In the watercolour drawings that he made in Italy during his first visit there, in 1819, the study has become a complete expression of the atmosphere of a particular place evoking the Mediterranean climate with a brilliance that proclaims the significance it held for Turner's imagination. But even these works must be regarded as preparatory: they were, or could have been, used to provide the starting point for fully developed statements destined for exhibition, or sale to a patron, or engraving as illustrations to a topographical book.

Sometimes a watercolour fulfilled all these functions, for Turner's work was much in demand, collected by a number of discerning men, and sought after to enhance the sales of popular travelogues and literary 'Tours'. Some of these, indeed, were conceived specifically as vehicles for the talents of Turner and his more eminent colleagues: the series of *Picturesque Views on the Southern Coast of England* occupied him between 1811 and 1824, and almost immediately after them an even more ambitious enterprise, the *Picturesque Views in England and Wales*, prompted a superb sequence of watercolours during the decade from 1825. In addition to these, Turner was engaged in his own printmaking ventures, notably the famous *Liber Studiorum*, modelled on Claude's *Liber Veritatis* and ostensibly a published survey of his own art, which appeared in a succession of issues from 1807 to 1819. These plates were often etched by Turner himself; he engaged professional engravers to add mezzotint tone, but towards the end of the project he seems to have become increasingly interested in the mezzotint process himself, and personally executed a few plates which were never published. This interest was further stimulated by his collaboration with the mezzotinter Thomas Lupton on two series of plates after his designs illustrating *Rivers of England* and *Ports of England*. While these were being published, between 1823 and 1828, he experimented with another group of his own mezzotints, on themes of night and storm which lend themselves well to the dark velvety quality of the medium. Some of the most atmospheric of the colour studies of this period are related to these essays in printmaking.

It is perhaps no accident that at precisely this time – the middle or later 1820s – his work in both watercolour and oil was becoming increasingly brilliant in colour and high in key, though it is true that the gradual lightening of his palette had been noticed by critics since about 1810. Now, the typical greens and ochres of the 1810s, which had themselves succeeded the sombre 'sublime' colouring of his early mountainous and architectural subjects, gave way to an almost infinitely varied palette in which vermilion, yellow, indigo, blues and greens are subjected to an astonishing range of combinations and recombinations. The *Picturesque Views in England and Wales* (ninety-six published designs in all) mark the apogee of this development. They are considerably smaller than the large early watercolours, but incorporate a wealth of detailed information about the appearance of the places depicted, their climate and geography, the activities of their inhabitants at work and at leisure: they are complete documents of the life of the period, assembled with

all the fascination of a novelist and all the meticulousness of the topographical draughtsman. The mass of detail that is essential to these remarkable drawings is put in with minute touches of a fine brush: but in order to maintain the breadth and vigour of the design as a whole Turner still conceived and largely painted his watercolours with the sweeping washes that he had used for his Welsh views of the 1790s. One eye-witness account of the process tells us that Turner would work on several drawings at once – a fact which throws light on his lifelong preference for executing watercolours in series: 'he stretched the paper on boards and, after plunging them into water, he dropped the colours onto the paper whilst it was wet, making *marblings* and gradations through the work. His completing process was marvellously rapid, for he indicated his masses and incidents, took out half-lights, scraped out high-lights and dragged, hatched and stippled until the design was finished.'

There are in the Turner Bequest a number of sheets which are apparently half-finished watercolours in which these processes can be seen arrested before completion; and it is clear that in the course of his preparation for his elaborately-conceived designs he also had recourse to studies which exist simply to establish the overall colour harmonies and rhythms of each. These have sometimes been construed as finished works in their own right, belonging to a late stage in Turner's development when he had abandoned the depiction of specific detail altogether. But they are nothing of the kind; rather stages *towards* a final composition in which specific detail is as abundant as ever, but never allowed to clog or impede the dynamic of the design as a whole. These 'colour structures' show us Turner's extraordinary ability to analyse the most complex effects into their fundamental parts, to isolate these and reintegrate them without sacrificing either conviction of detail or spontaneity of general effect.

Yet other developments in his exploration of the medium of watercolour took place in these closing years of the 1820s. He demonstrated with even greater virtuosity his complete command of scale when he undertook to design small vignette illustrations for a number of books, including the poetical works of Byron and Samuel Rogers, and the poetry and prose of Sir Walter Scott. These tiny drawings are as richly invented and as spacious as his largest paintings; whole worlds of experience are compressed into their three or four inches. They again demonstrate the vivid, enamel-like colour that was so much a feature of his art at this period. This is equally apparent in drawings of a very different type and technique: the views that he made for the Tours of the Loire and Seine which were published in 1833-5 as part of a much larger scheme, never completed, embracing the principal rivers of Europe. Once more the size of the sheets is small but the scale expansive; but in these drawings there is no meticulous hatching with a fine brush in watercolour on smooth white paper or card: rather a bold sketching in bodycolour on rough blue paper torn into small rectangles and apparently carried about, like a disbound notebook, in Turner's pocket. He took a similar wad of these sheets with him to Petworth in Sussex when he went to stay there with his patron Lord Egremont in 1828 or thereabouts; his notes in rich bright bodycolour of the house and its inmates are among the most vividly spontaneous of his works. In them, as in the 'Rivers of Europe' drawings, colour seems liberated from all constraints, and a new chromatic expressionism is born.

All these experiments were to have a considerable effect on Turner's use of watercolour thereafter. In the course of his extensive European travels in the 1830s the role of the colour study underwent a change. It had always been a form that could respond flexibly to any demands he made of it; it now became increasingly a receptacle in its own right for some of his most profound ideas. He never relinquished his concern with finished works, elaborate statements of highly organised and deeply considered groups of ideas; but the studies

that preceded these became increasingly dense themselves. They illustrate a short-circuiting, as it were, of the creative process, whereby the initial sketch from nature is transmuted, even as it is put down on the paper, into a poetic utterance in which reality is forged into something different and novel. It is no longer possible, indeed, to say precisely how the drawings are produced. Sometimes, still, he sketches on the spot, and afterwards at his inn or even, perhaps, back home in London he adds colour; but very often pencil outline and washes of colour are inextricably woven together with such compactness that we cannot identify which preceded which. No works demonstrate this better than the remarkable sequence of studies that Turner made in Venice, probably on his third and last visit there, in 1840. These vary in type from virtually complete, self-sufficient statements to rapid and elusive notes; yet almost all enshrine a fully-realised sense of place and atmosphere. He seems never to have felt inclined to take them to the logical next stage, the 'finished' watercolour, though there are a number of oil paintings of Venetian subjects dating from shortly after 1840, several of which were shown at the Royal Academy, and these represent Turner's public expression of his feelings about Venice. These watercolour studies were not, as a rule, used as steps towards oil paintings, but with one or two of the Venetian pictures that relationship does exist: at this point the two media approach each other closely, and it has often been observed that the technique of the paintings seems to have been deliberately modelled on that of the watercolours. The studies themselves, nevertheless, are often of such an achieved and consummate beauty that they attain, on their much smaller and more intimate scale, to a breadth and grandeur quite as compelling as that of the oils.

Oddly enough, the interrelationship of oil and watercolour that occurs with the Venetian subjects was not a feature of his next great series of studies: those made on his tours of Switzerland in 1841, 1842, 1843 and 1844. In each of these years he explored different parts of Switzerland, always centring his travels on the city of Lucerne and its great Lake. The attraction of this particular spot, which he had first visited in 1802, was probably the immensity of its spaces, the combination of a magnificent stretch of water with grand mountains: here, Turner could exercise his supreme gift of evoking the vastness of nature, and could combine endlessly the open tranquillity of lake and sky with the brooding closeness of the mountains. Another of the Swiss towns which afforded him special delight, and inspired many drawings, was Fribourg, where a different, equally powerful contrast operates: that between the lowering cliffs of the gorge in which Fribourg is built, and the clustering medieval buildings dwarfed by those cliffs, which express the multifarious lives of the inhabitants of the ancient city.

But whereas Venice led him on to paint a sequence of oil paintings, Switzerland seems to have demanded to be expressed in watercolour. Turner felt some special need to develop his experiences of the lakes and mountains as elaborate finished watercolours which, in accordance with his lifelong habit, he executed in sets, usually of ten. The subjects to be finished were selected by his patrons to whom he asked his agent, Thomas Griffith, to show a series of 'sample' studies partly worked up from sketches made on the spot. The first of the finished sets made its appearance in 1842, and the ten watercolours that compose it are perhaps the most perfect that he ever made; in them the breadth of his fascination with nature and with humanity is synthesised into an organic unity more dynamic and at the same time more contemplative than the England and Wales designs that preceded them. These are the works of an old man who, after a lifetime of study, has found perfect satisfaction in meditating on nature's grandest phenomena. They may be placed beside his more spectacular, and therefore better-remembered, records of catastrophe – storm, avalanche, flood – as an equally important aspect of his art and, perhaps, his

ultimate reflection on the world he lived in.

So insistent was his urge to make finished watercolours of these subjects, that he continued to produce them even when his patrons had almost entirely abandoned him as incomprehensible. Even after he had lost all hope of selling, he planned further, still more ambitious sets of views in his obscure place of retirement by the Thames at Chelsea. The habit of 'finishing' pictures was engrained in him; it was part of his earnest wish to communicate with the public. His reputation as a lonely, miserly man dedicated to his art, and the huge quantity of exploratory and experimental sketches and studies that became the property of the English nation after his death, have contributed to a popular view that he was essentially a 'private' artist, that he despised public opinion and did not intend his work to be generally understood. This is not at all the case. He was eager for popular recognition and much hurt by the misunderstandings of critics. He was, indeed, in many ways a very private person: he lived secluded, either with his old father or, towards the end of his life, with a devoted housekeeper; he worked hard and did most of his travelling, both in Britain and all over the Continent, unaccompanied. But the art that grew from this privacy was his true social life, his discourse and conversation: it was intended for the public – it is about people, the world they live in and the suffering and delight it affords all human beings. It is the most wide-ranging and profound study of nature in its human context ever made by a painter and, just as it explores every aspect of watercolour, comprehends also the whole gamut of human experience.

When Turner died in 1851 he bequeathed to 'the Public' all the finished works in oil that remained in his studio. Such was his sense of the importance of his achievement that he had even taken special precautions to ensure that certain of his canvases were not sold, but 'kept together' as he liked to insist, so that their value might be properly appreciated. He stipulated in his Will that a 'Turner Gallery' was to be built to house these pictures. Owing to litigation by members of his family (with whom he had never been on close terms during his life) the large sums of money he had accumulated for this and other purposes connected with his art were dispersed, but the National Gallery received the entire contents of his studio instead. Apart from about three hundred oil paintings and sketches, this included some 260 sketchbooks and thousands of separate leaves. The majority of these are pencil drawings and colour studies; there are a few series of finished watercolours, like the *Rivers* and *Ports of England* and vignette illustrations to Rogers's poems. Such a wealth of material enables us to appreciate the extraordinary diversity of his working methods, the stylistic variety of the works he produced over the span of his long career, and the continuity of his thought as an artist concerned with every aspect of life around him and the ways by which that life can be transmuted into art. Despite the considerable differences in subject-matter and style between the earliest works and the latest, there lies behind them all the relentless spirit of experiment, that earnest search after the beauty inherent in every visible thing, which makes each drawing a new and surprising experience: even the smallest contains worlds of meaning, and evokes limitless space. As his contemporaries realised, with disbelief, he was an artist for whom the physical barriers of his chosen medium were unimportant – or at least, merely constraints that the hero rejoices effortlessly to overcome.

The awareness of Turner's heroic achievement hung over the endeavours of watercolourists throughout the rest of the nineteenth century, rather as Beethoven's did for composers. Indeed, little has been done in watercolour since that he did not in some way anticipate or perfect. But it was in the technique of watercolour painting that he had the greatest influence on his contemporaries, and in copying his complex processes in order to create elaborate, highly-detailed subjects they produced works that seem to us now

the reverse of prophetic: painstakingly wrought scenes of rustic life, in England or Italy, which embody the spirit of the Victorian period. One of the finest of these watercolourists, Samuel Palmer, wrote of Turner's art that it was 'like what Paganini's violin playing is said to have been; something to which no one ever did or will do the like.' This tribute sums up the element of Romantic virtuosity that is an essential ingredient in Turner's work; but it omits the more fundamental merits that Palmer no doubt appreciated, and which make Turner an artist not only for the nineteenth century, but for every age: his immense range, his penetrating intelligence, and, above all, his compassionate concern for everything that has to do with the world that human beings inhabit.

THE PLATES

*The captions give title, date, medium and sheet
dimensions of each work, followed by the reference number
in A. J. Finberg's 'Inventory of the Turner Bequest' (1909),
and the Tate Gallery accession number.*

1 The Oxford Street Pantheon,
 the morning after the fire

1792 Pencil and watercolour

516 × 640 mm

IX - A D00121

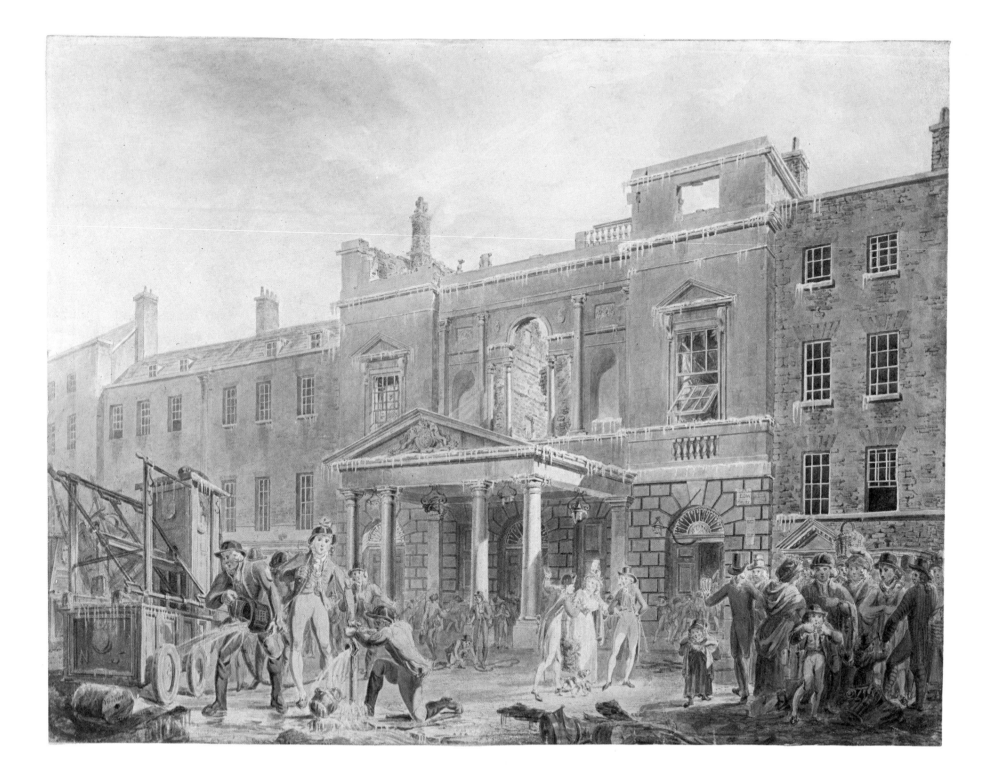

2 A rocky shore with storm-tossed boat

1792 Pencil and watercolour

162 × 232 mm

XXIII-R D00392

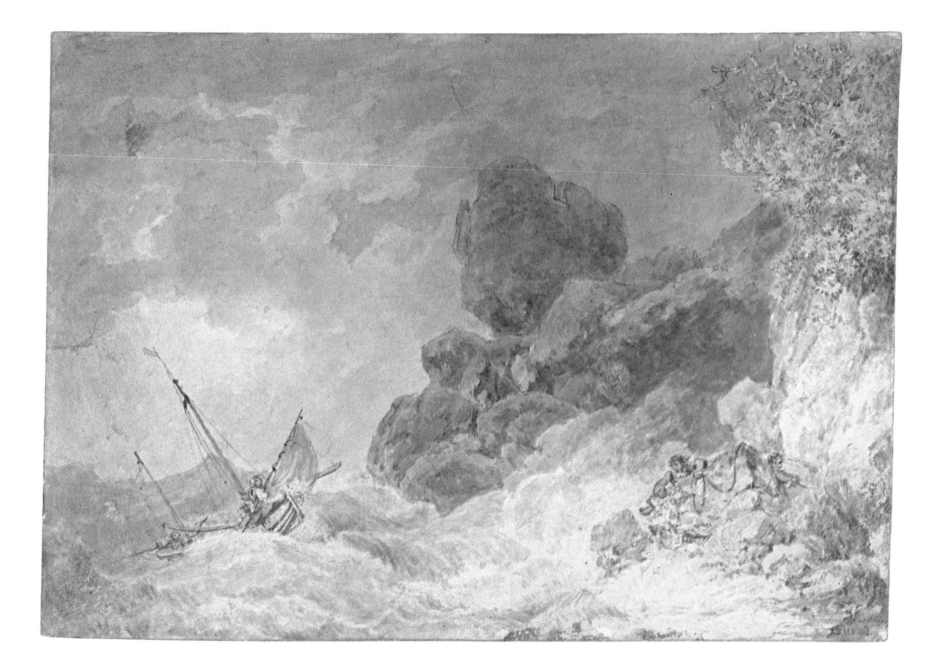

3 Oxford: St. Mary's from Oriel Lane

1793 Pencil and watercolour

274 × 217 mm

XIV-C D00156

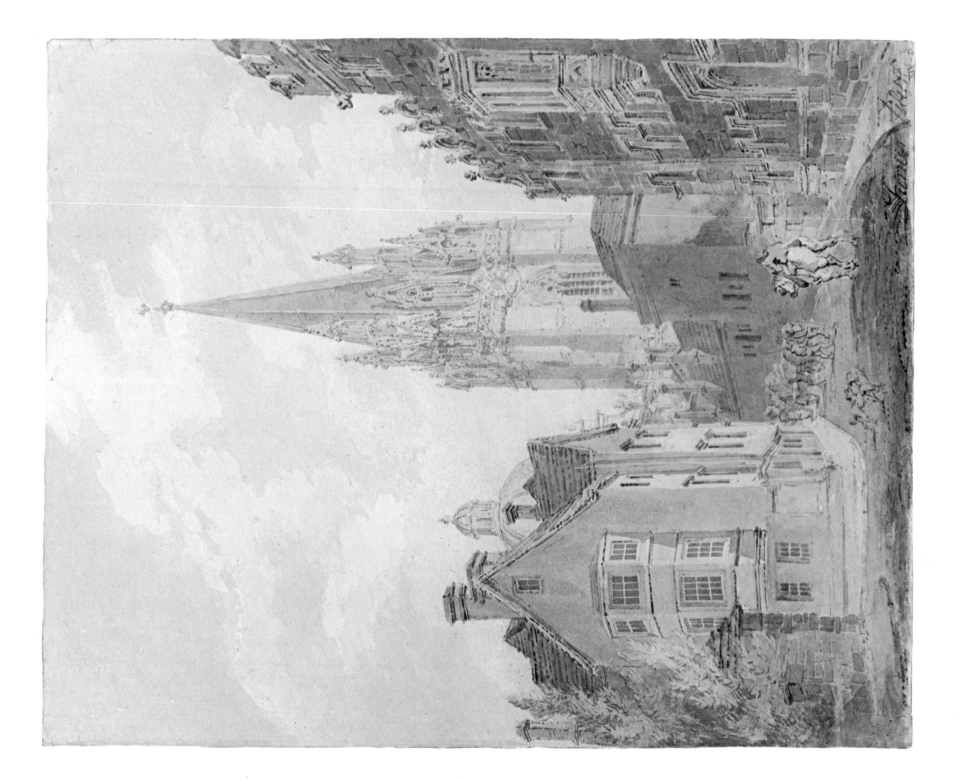

4　Valle Crucis and Dinas Bran

1794–5　Watercolour

464 × 377 mm

XXVIII-R　D00703

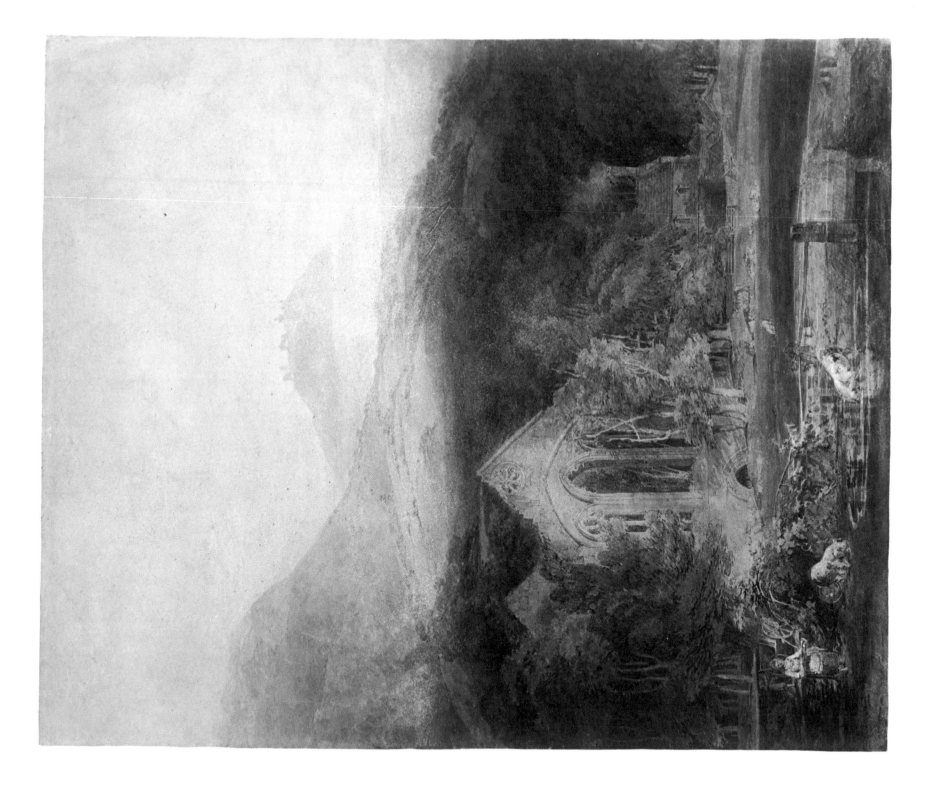

5 St. David's Head

1795 Watercolour

201×265 mm

XXVI-29 D00582

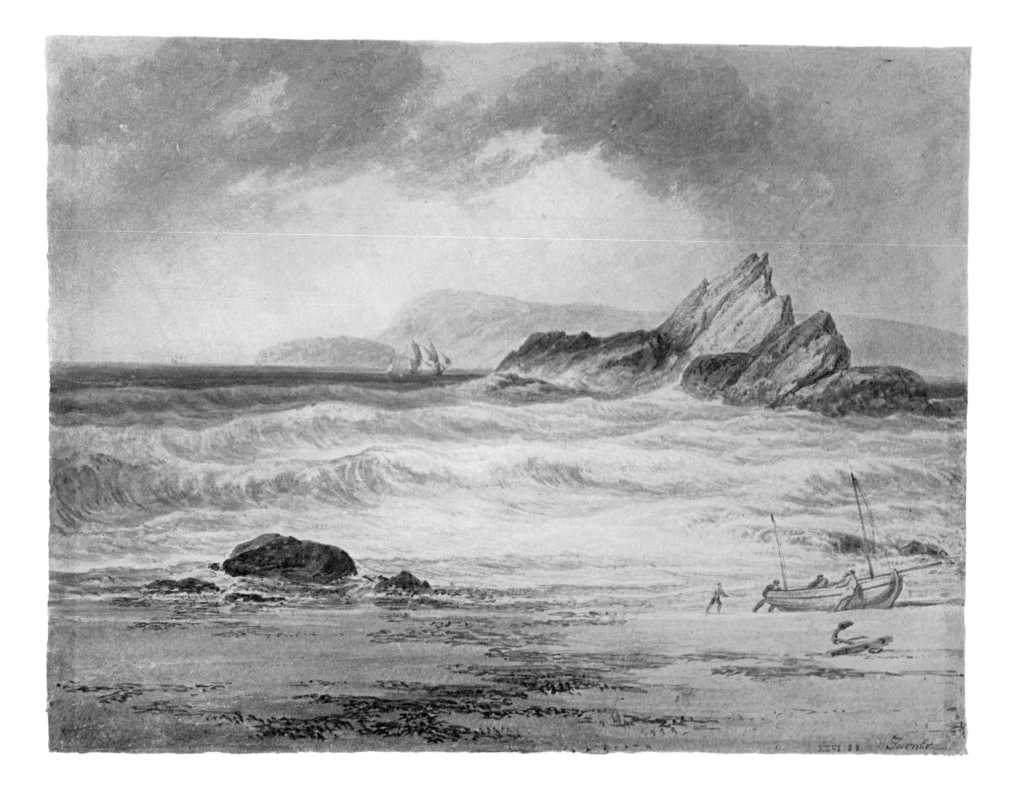

6 Leghorn

1796 Pencil and watercolour

432×554 mm

XXXIII-g D00904

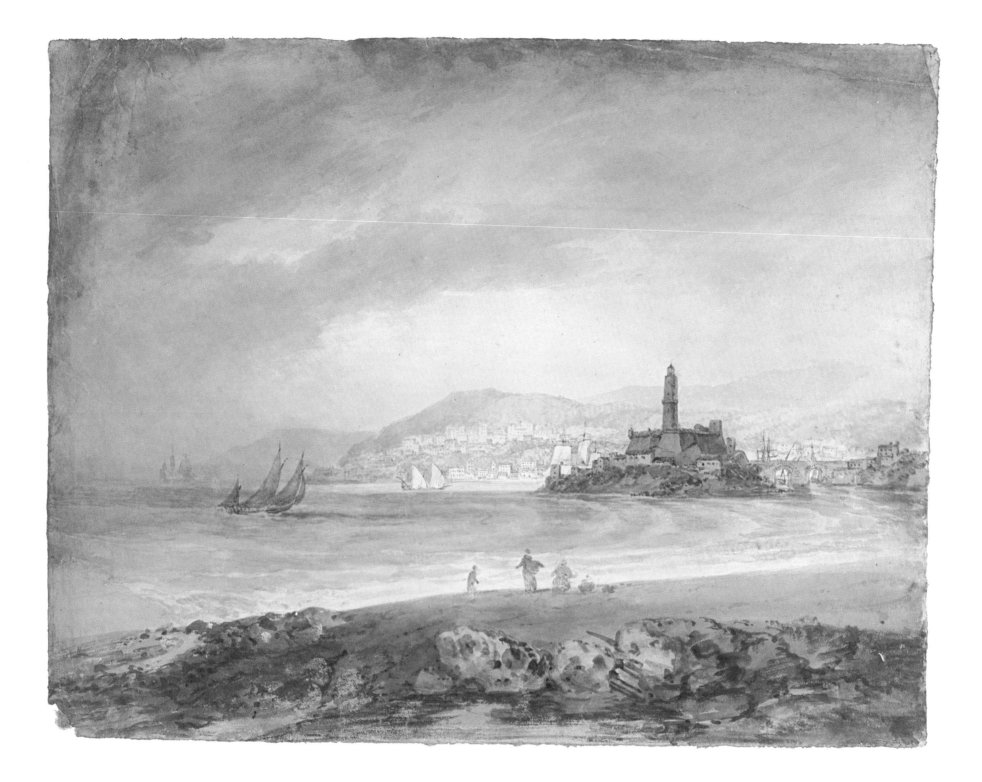

7 Small boats beside a man of war

1796 Watercolour and bodycolour

359 × 592 mm

XXXIII-e D00902

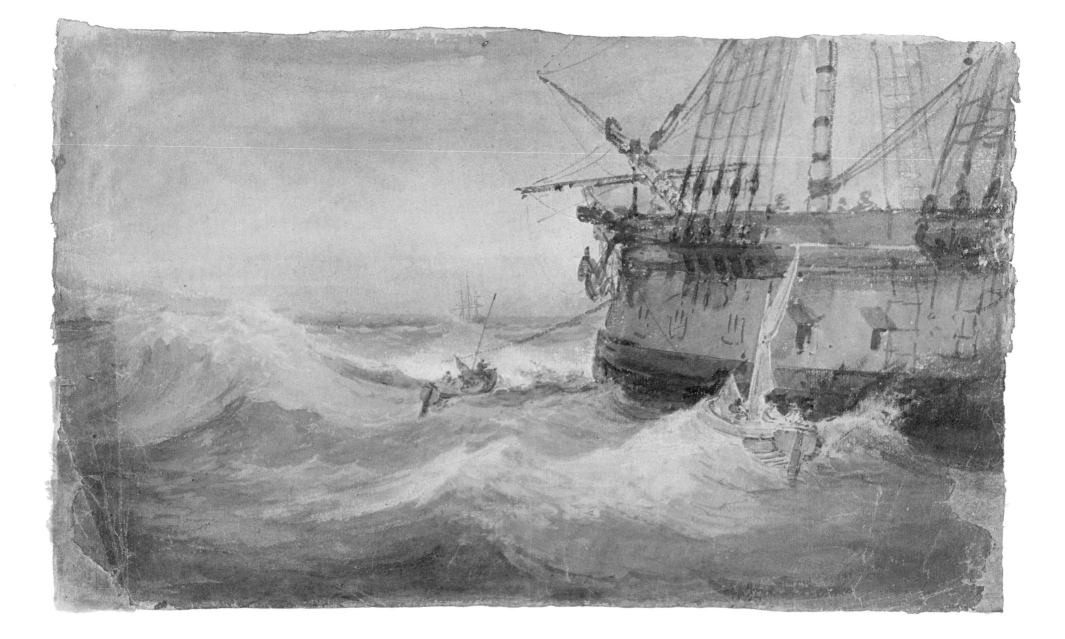

8 View in the Lake District –
 probably Coniston

 1797 Pencil and watercolour
 549 × 765 mm
 XXVI-L D01106

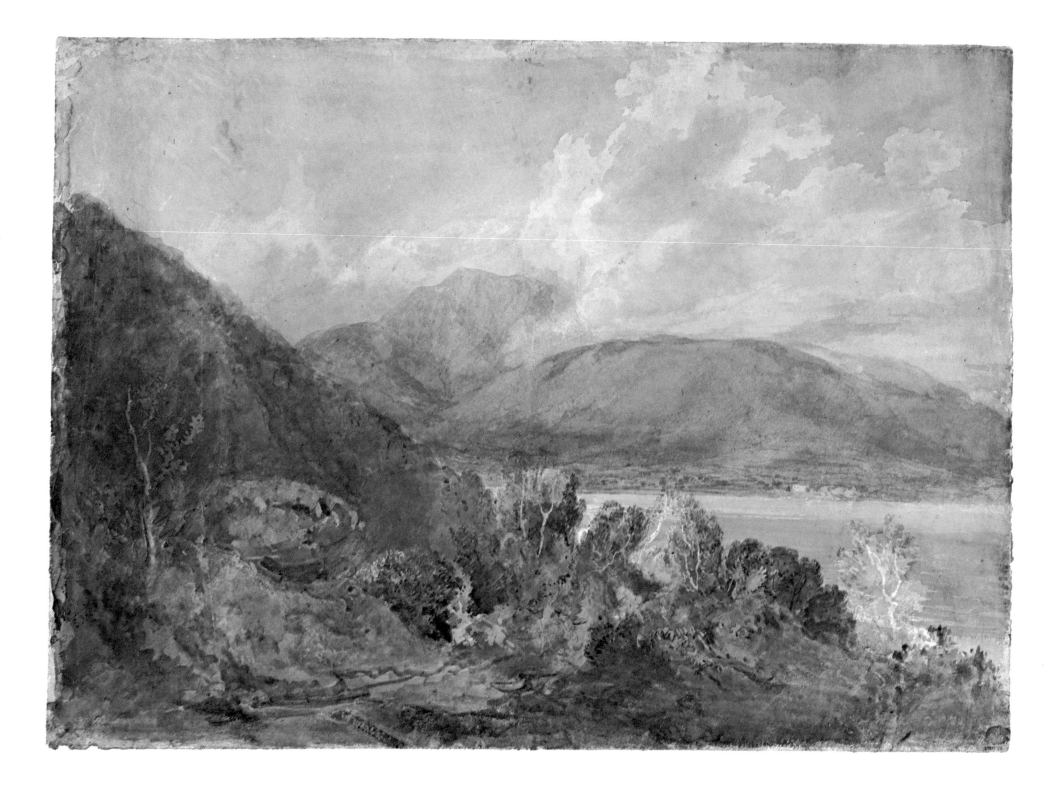

9 View on the Kent coast?

1797? Watercolour

211 × 270 mm

XXVIII-P D00701

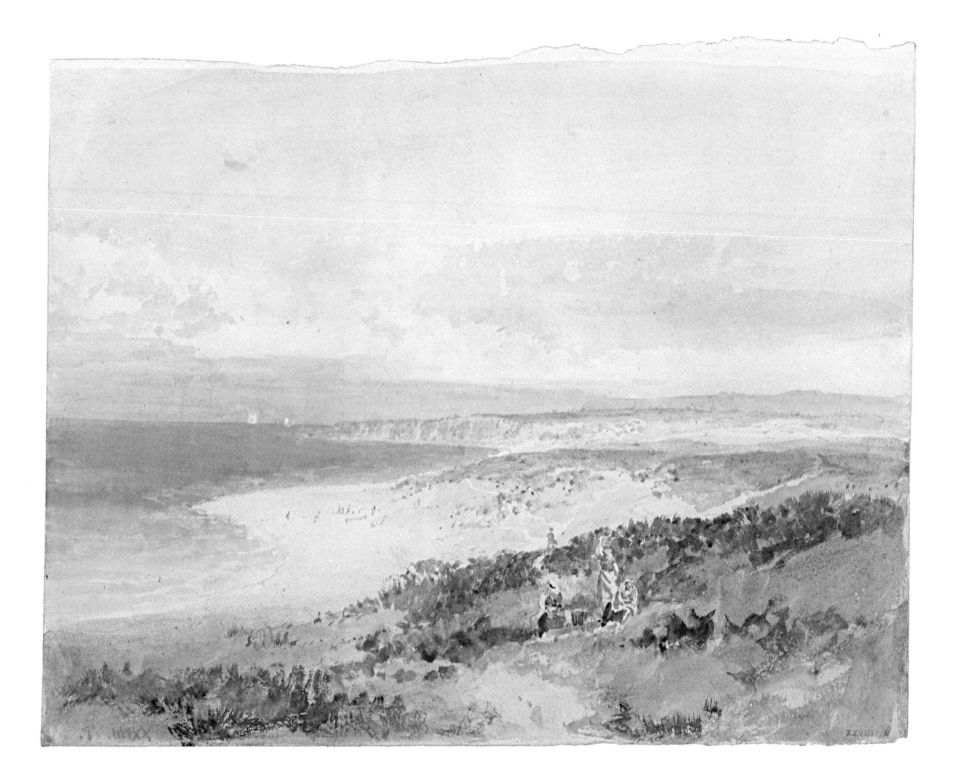

10 A view over Traeth Bach
 towards Snowdonia

1798 Pencil and watercolour
670 × 850 mm
XXXVI-U D01115

11 View in the Welsh mountains

with an army on the march

1799 Watercolour with stopping-out and some bodycolour

686 × 1000 mm

LXX-Q D04168

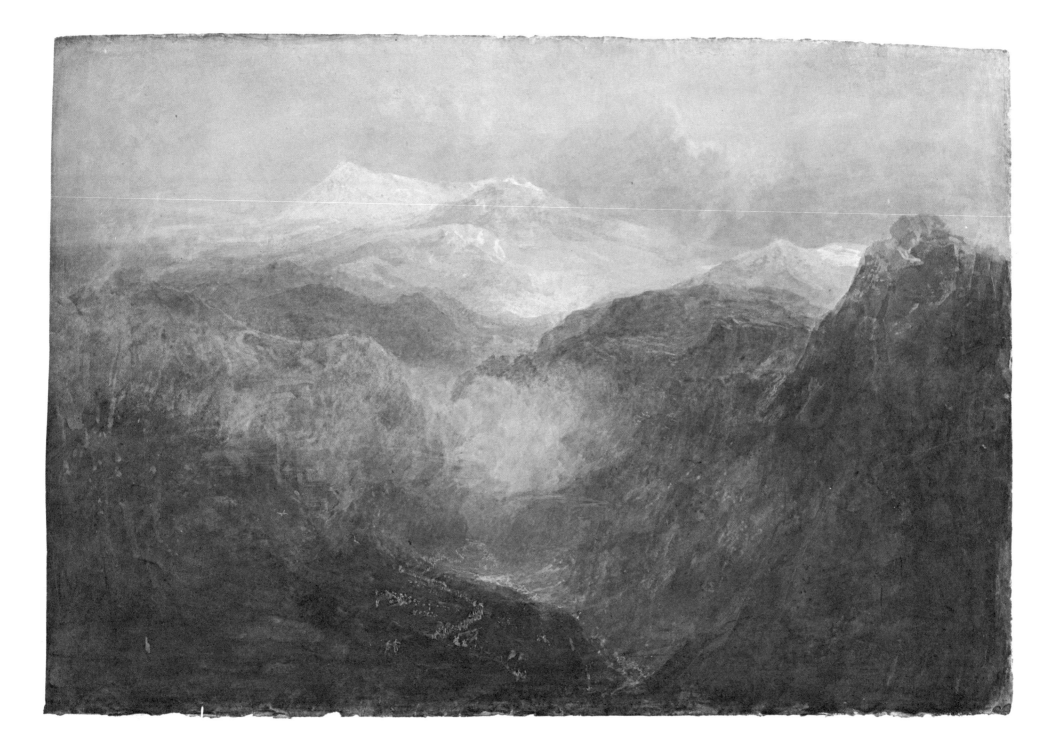

12 Caernarvon Castle, North Wales

1800 Watercolour

706 × 1055 mm

LXX-M D04164

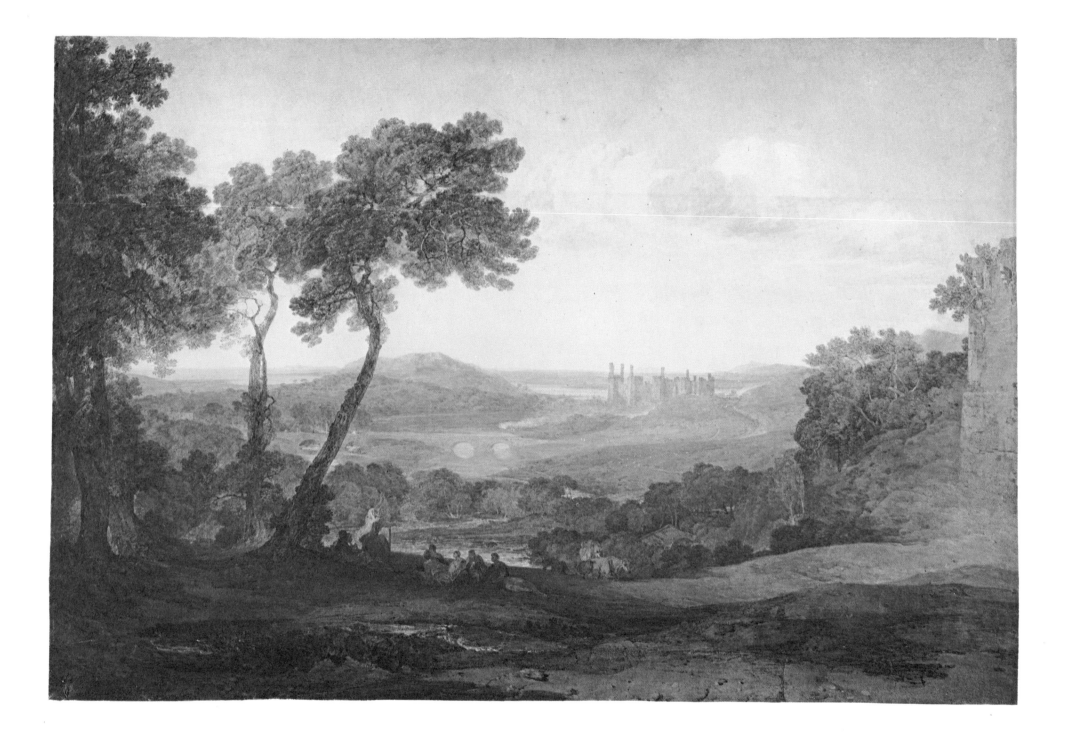

13　Inverary

1801　Pencil and bodycolour

332 × 485 mm

LVIII-9　D03388

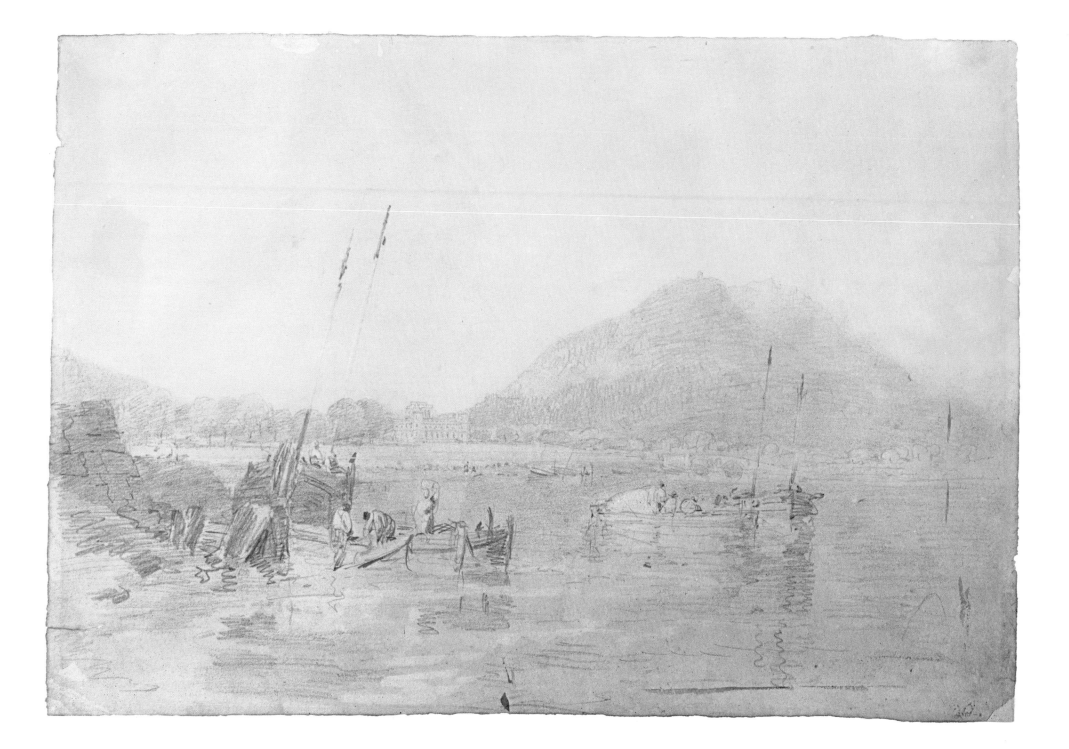

14 A Scottish Lake

1801–2 Watercolour

281 × 435 mm

LX-I D03640

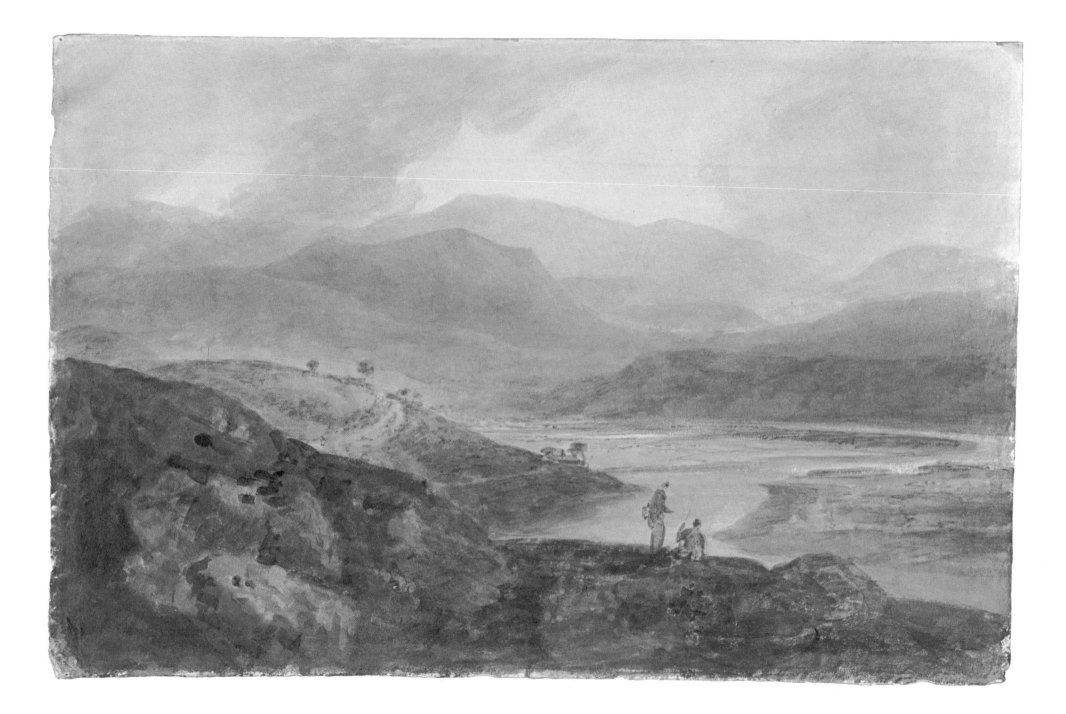

15 **Edinburgh from Calton Hill**

1802 Pencil and watercolour

662 × 1003 mm

LX-H D03639

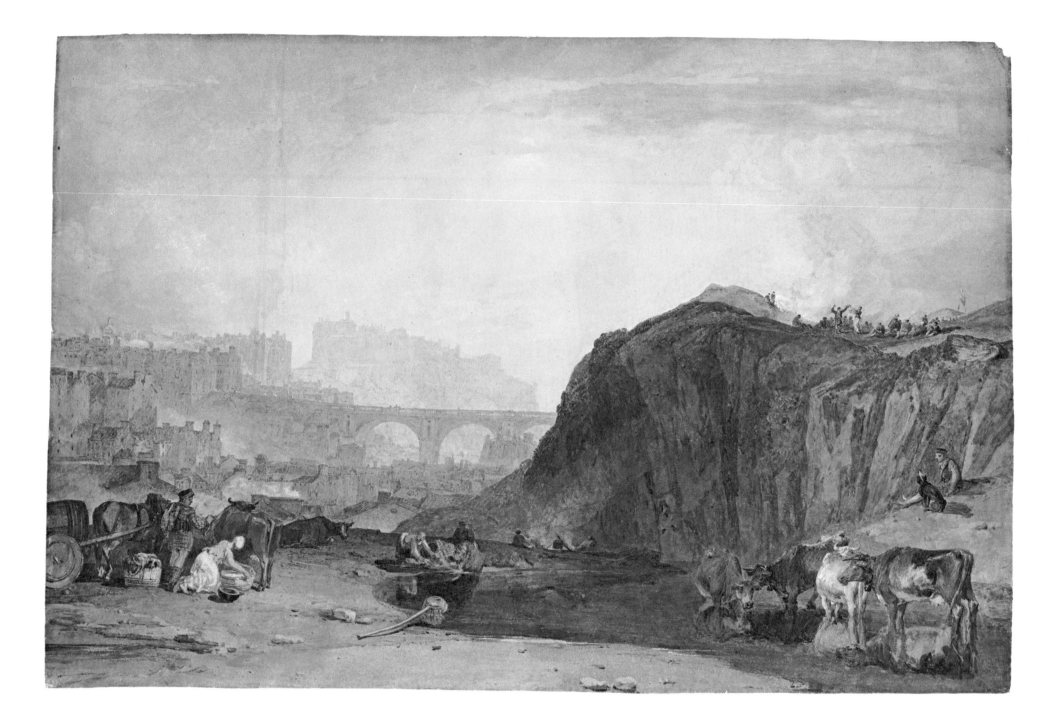

16 Grenoble

1802 Pencil and bodycolour

214×284 mm

LXXIV-14 D04506

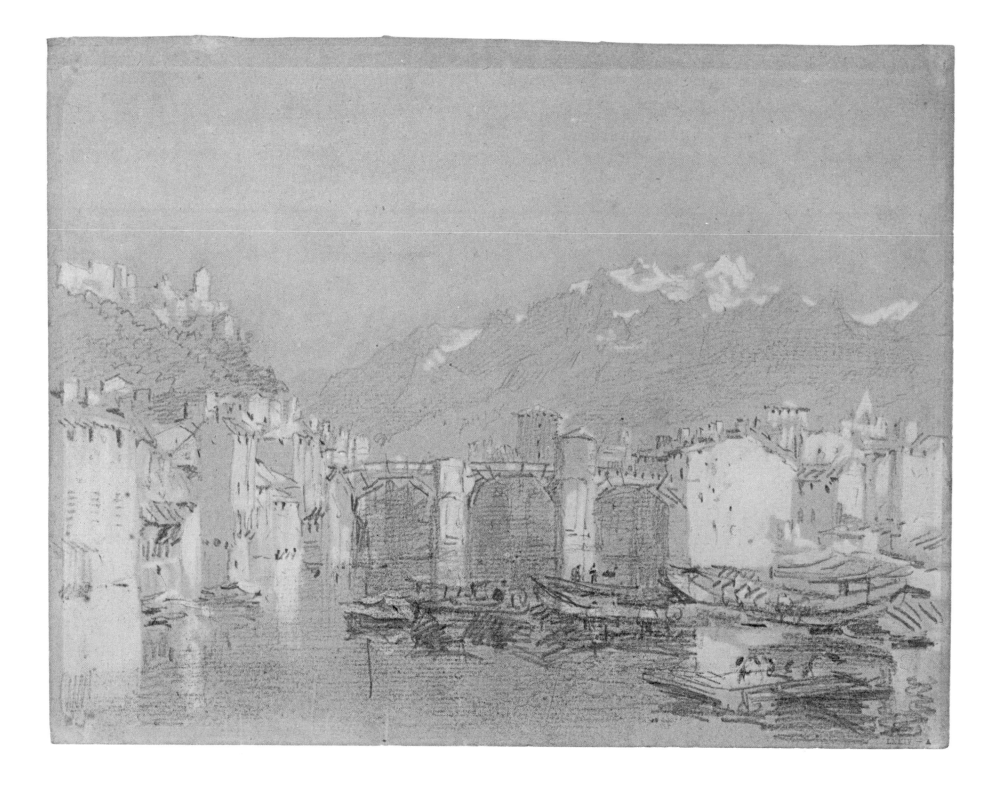

17 The Mer de glace, Chamonix

1802 Watercolour, heightened with bodycolour
and touches of chalk
314 × 465 mm
LXXV-23 D04615

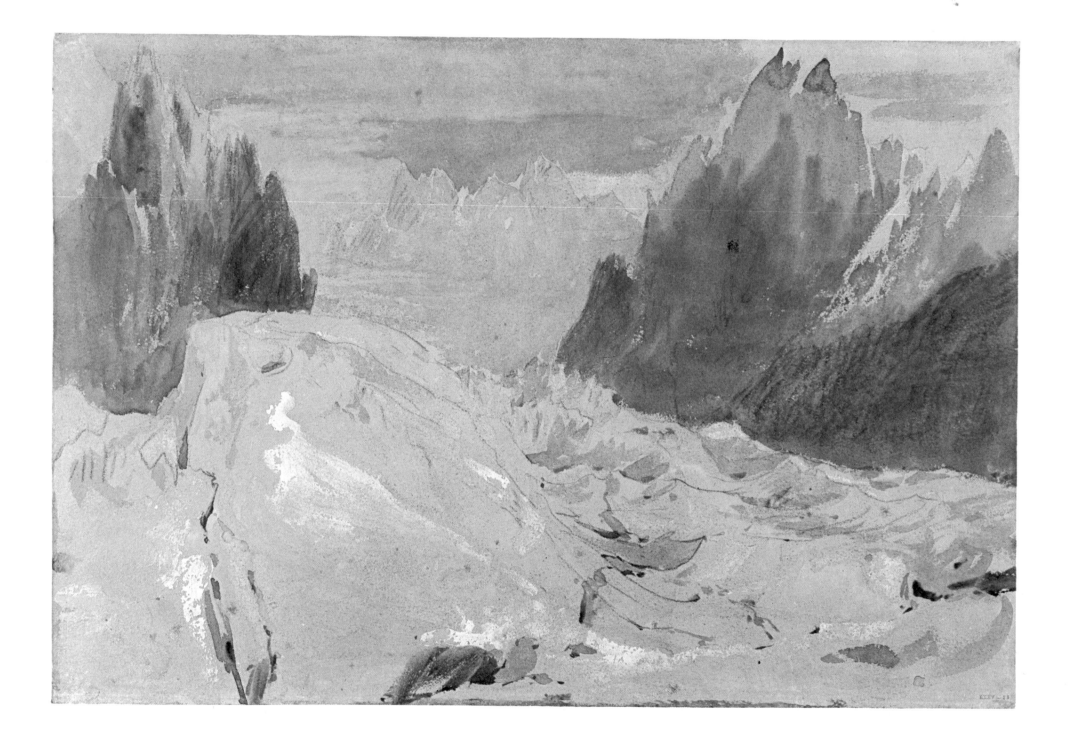

18 Mont Blanc from St. Martin

1802 Watercolour, with some bodycolour
and chalk
320 × 376 mm
LXXV-11 D04603

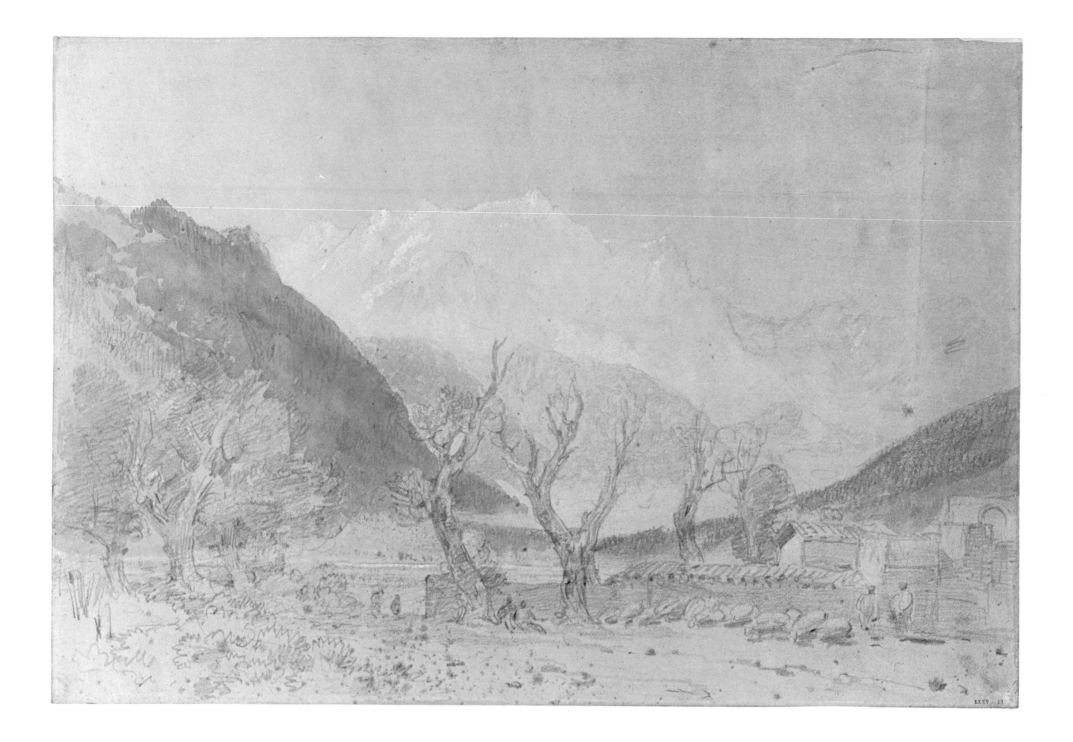

19　Composition study: a classical landscape

*c.*1805　Pen and brown ink

328 × 479 mm

CXX-Z verso　D40000

20 A group of trees beside the Thames

1806 Pencil and watercolour

257 × 368 mm

XCV-46 D05950

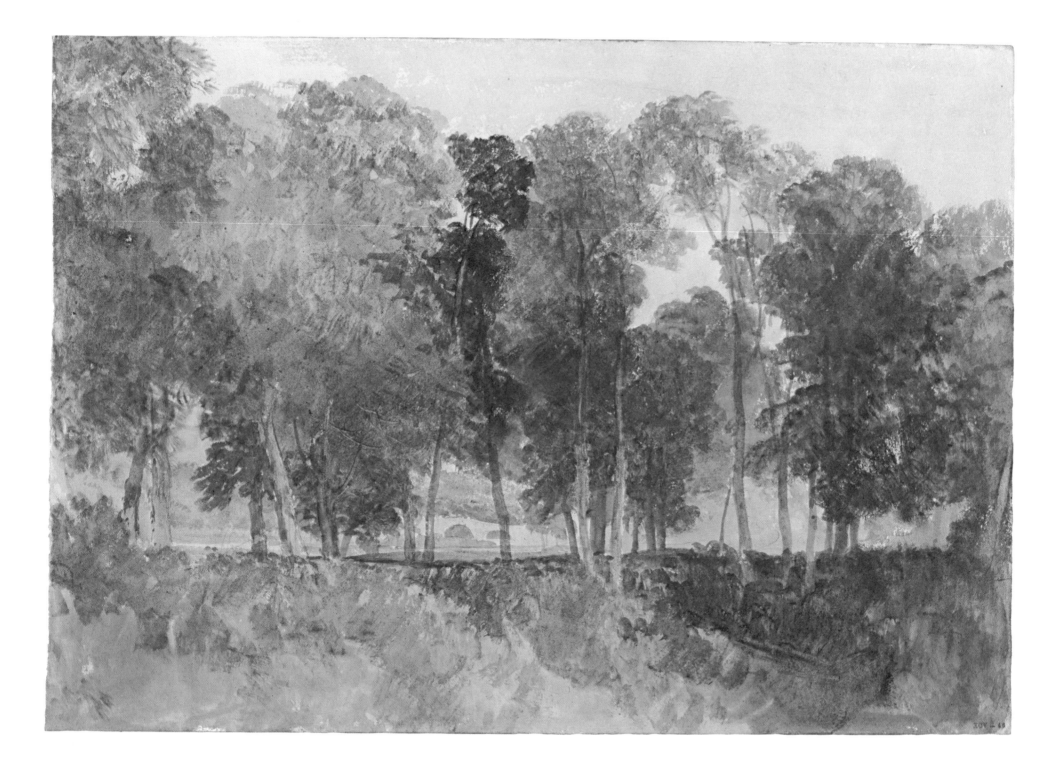

21 A blacksmith's shop

*c.*1807 Watercolour

197×275 mm

CXVI-H D08109

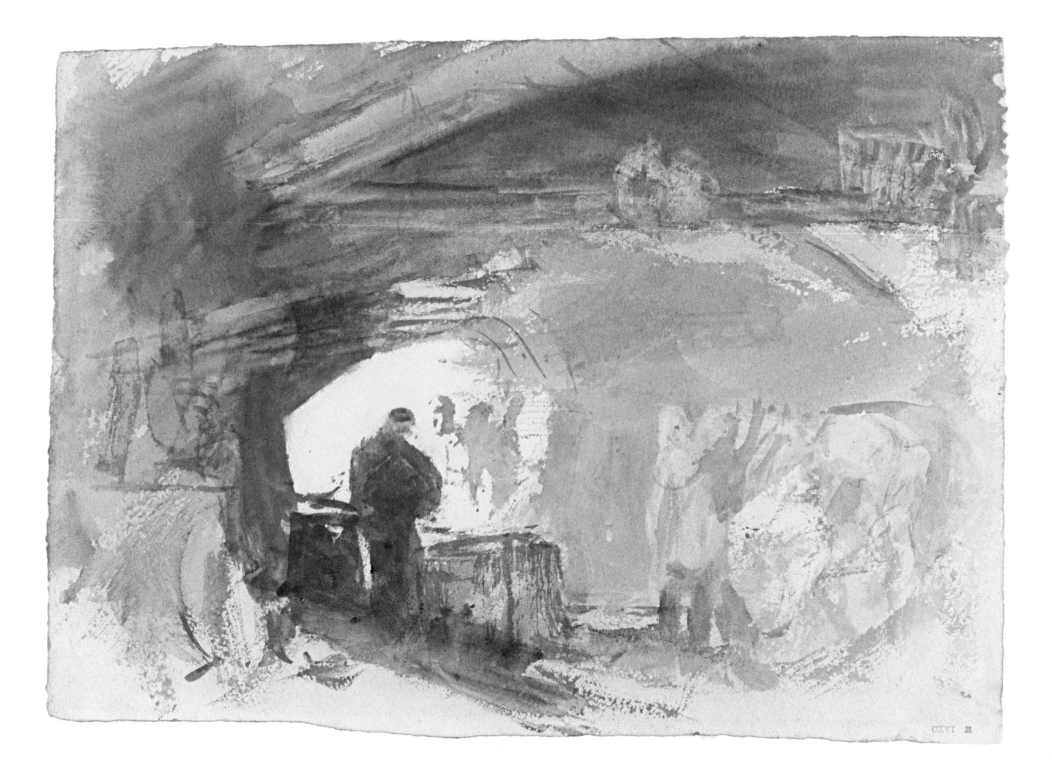

22 The Young Anglers

*c.*1809 Pencil, pen and wash

183 × 265 mm

CXVI-I D08136

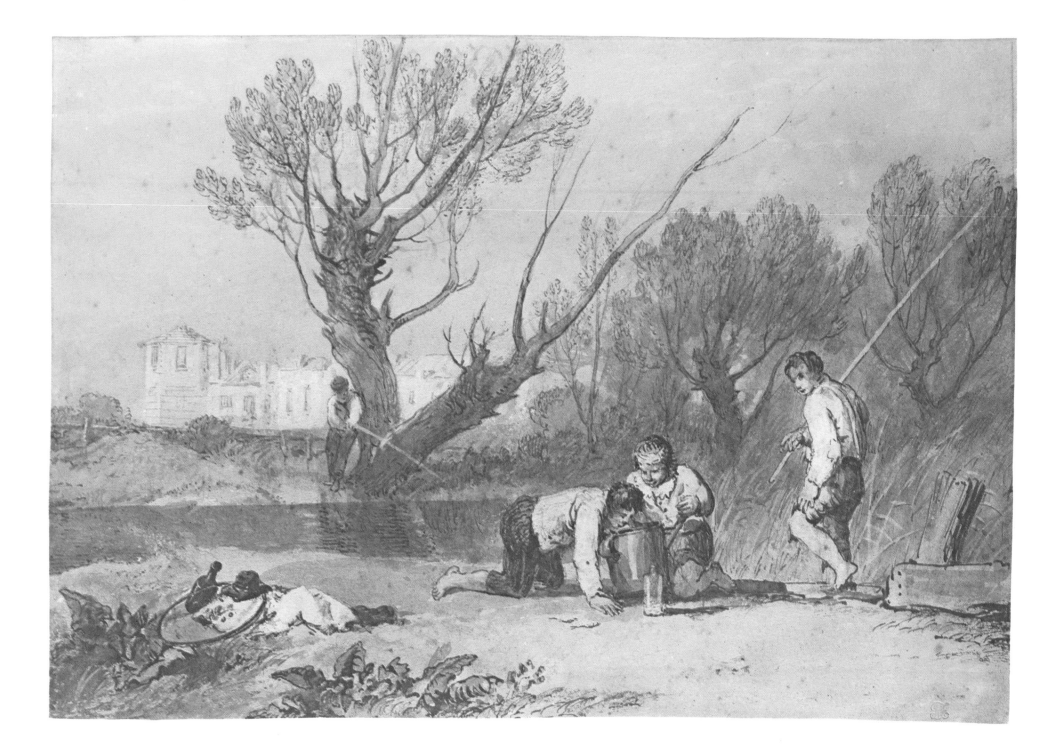

23 Perspective drawing: Pulteney Bridge

*c.*1810 Pencil and watercolour

674 × 1006 mm

CXCV-114 D17084

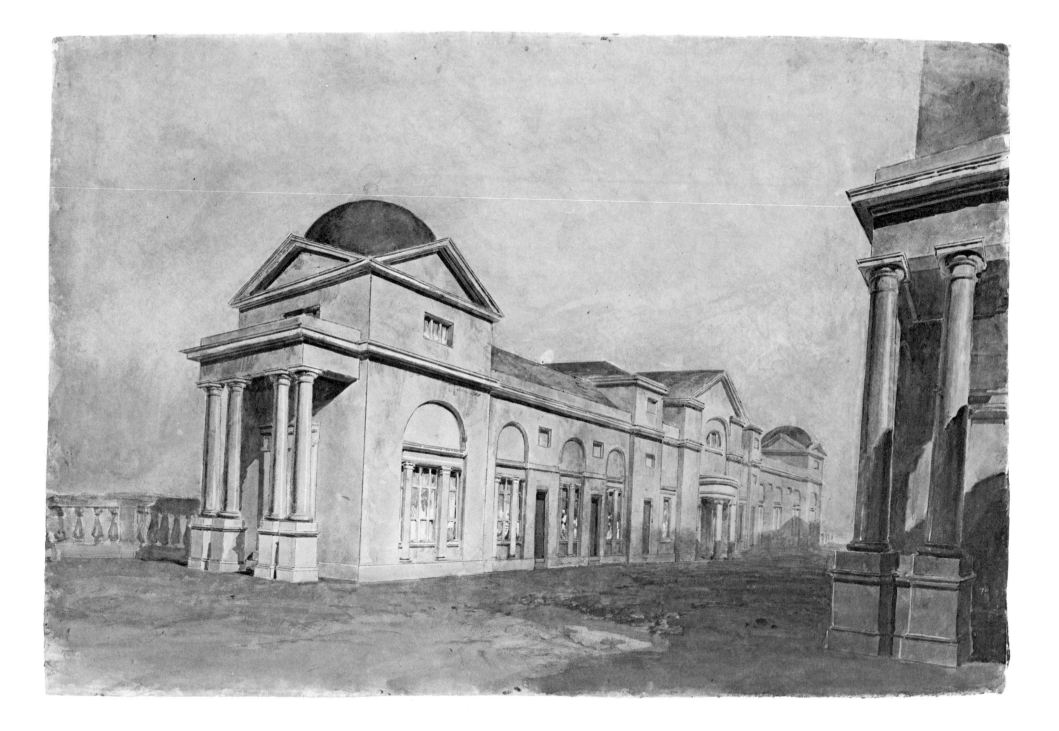

24 Hulks on the Tamar

c.1813 Watercolour

262 × 330 mm

CXCVI-E D17169

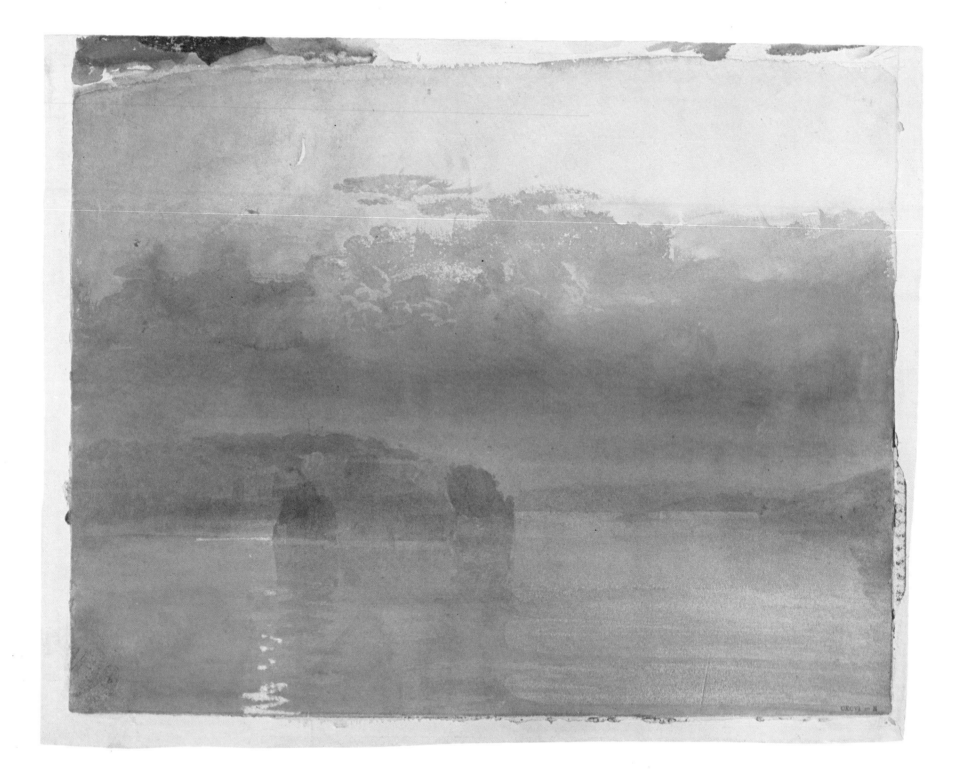

25 The Battle of Fort Rock,
Val d'Aosta, Piedmont, 1796

1815 Watercolour and bodycolour with
some scraping-out
696 × 1015 mm
LXXX-G D04900

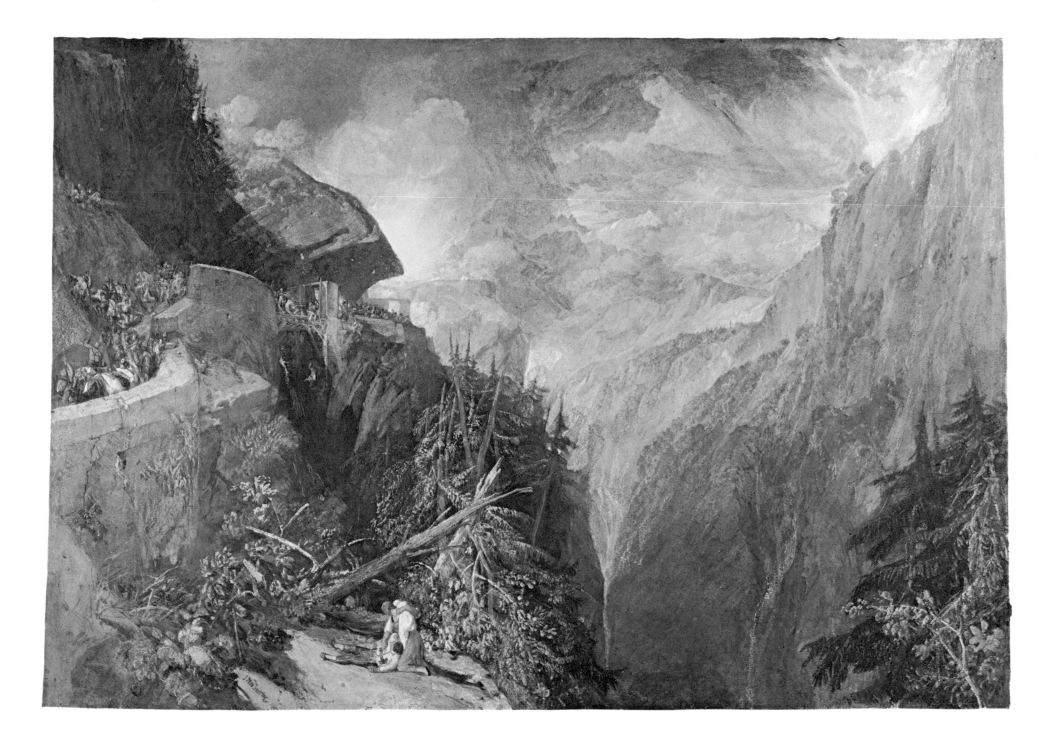

26 Study of four fish

*c.*1818 Pencil and watercolour

275 × 470 mm

CCLXIII-339 D25462

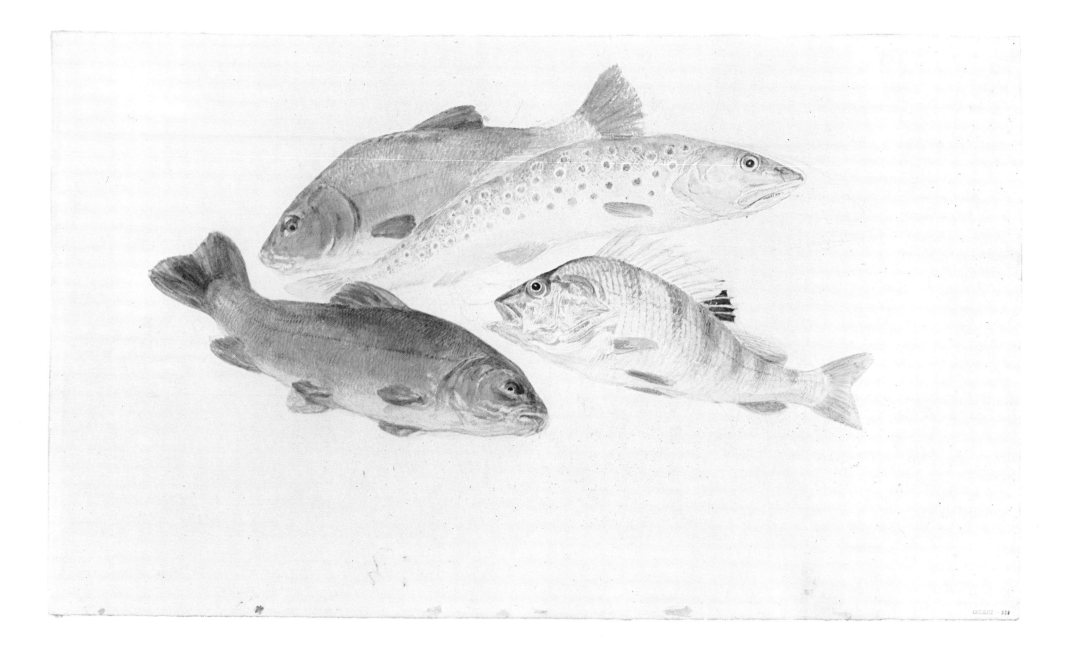

27 Moonlight at sea: the Needles

1815 Watercolour over pen and ink, and ink wash

209×277 mm

CXVIII-V D08176

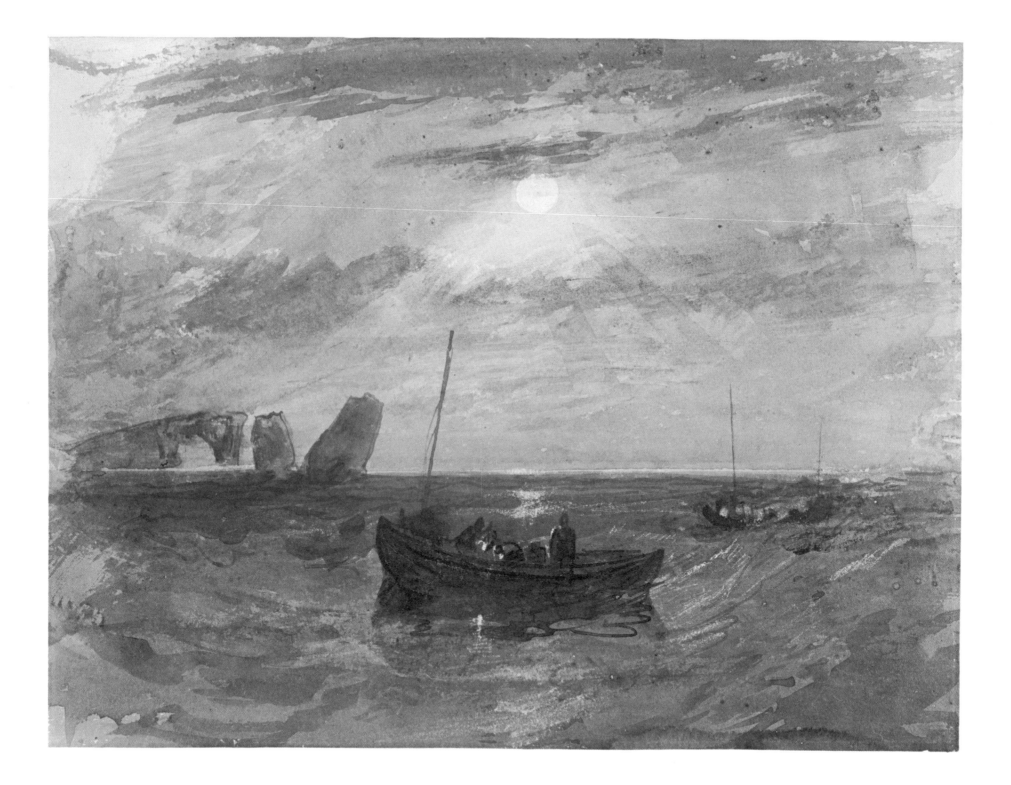

28 Lake Como

1819 Watercolour

224×286 mm

CLXXXI-2 D15252

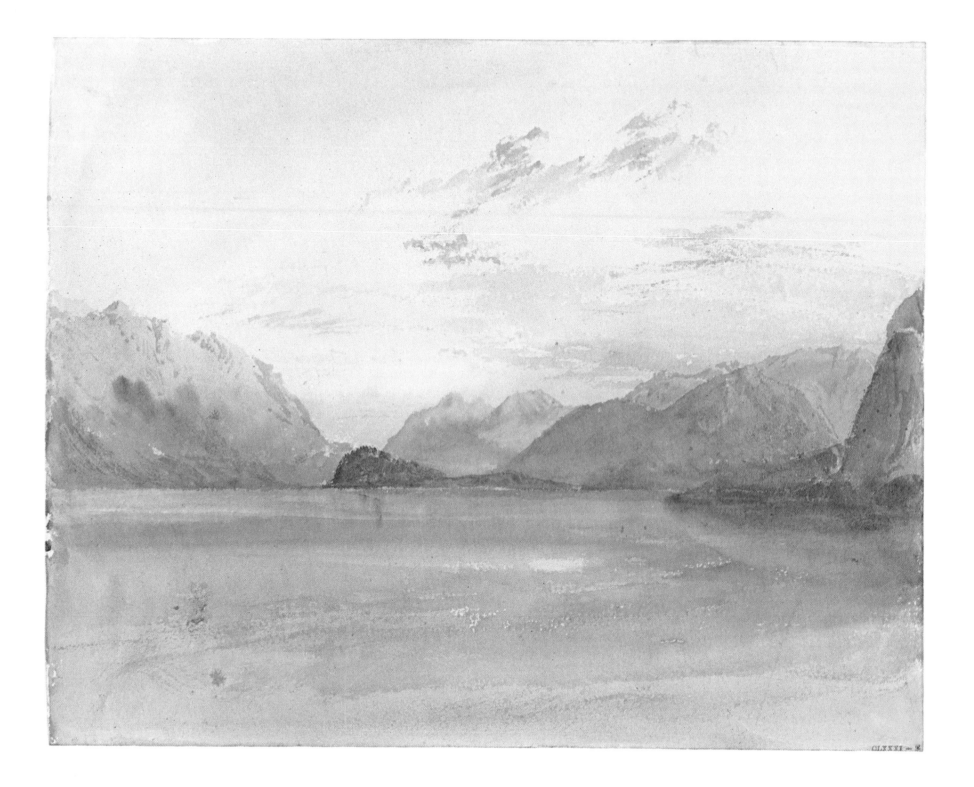

29 Venice: the Campanile and Doge's Palace

1819 Pencil and watercolour

225 × 289 mm

CLXXXI-7 D15258

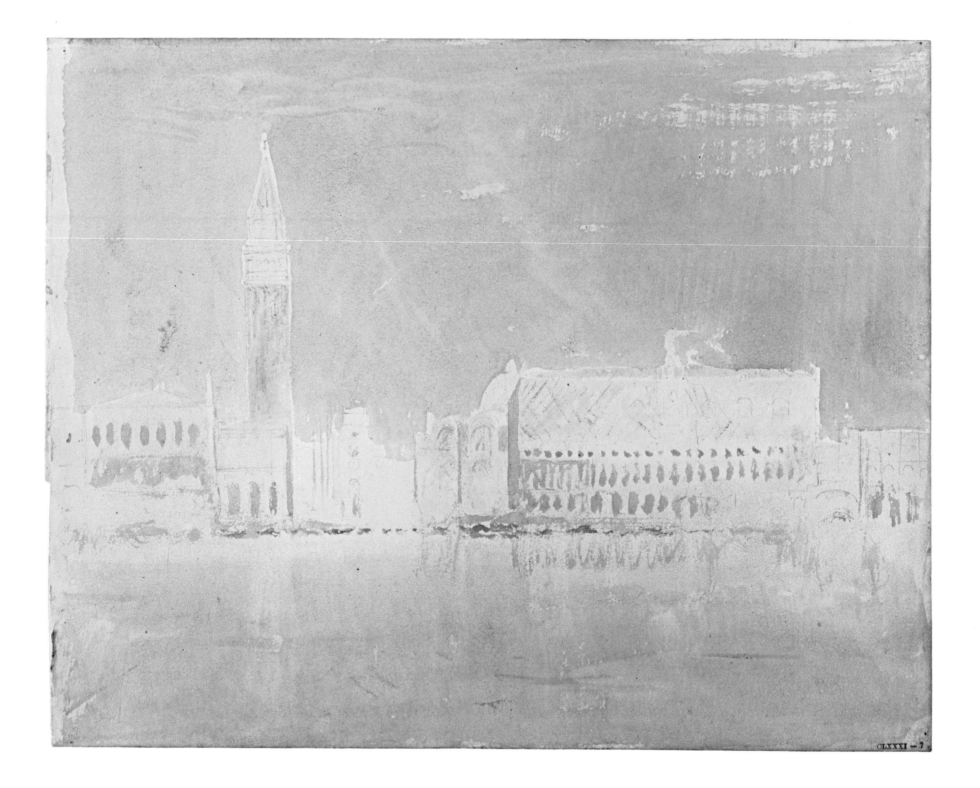

30 View over the Roman Campagna, morning

1819 Watercolour

254 × 401 mm

CLXXXVII-34 D16122

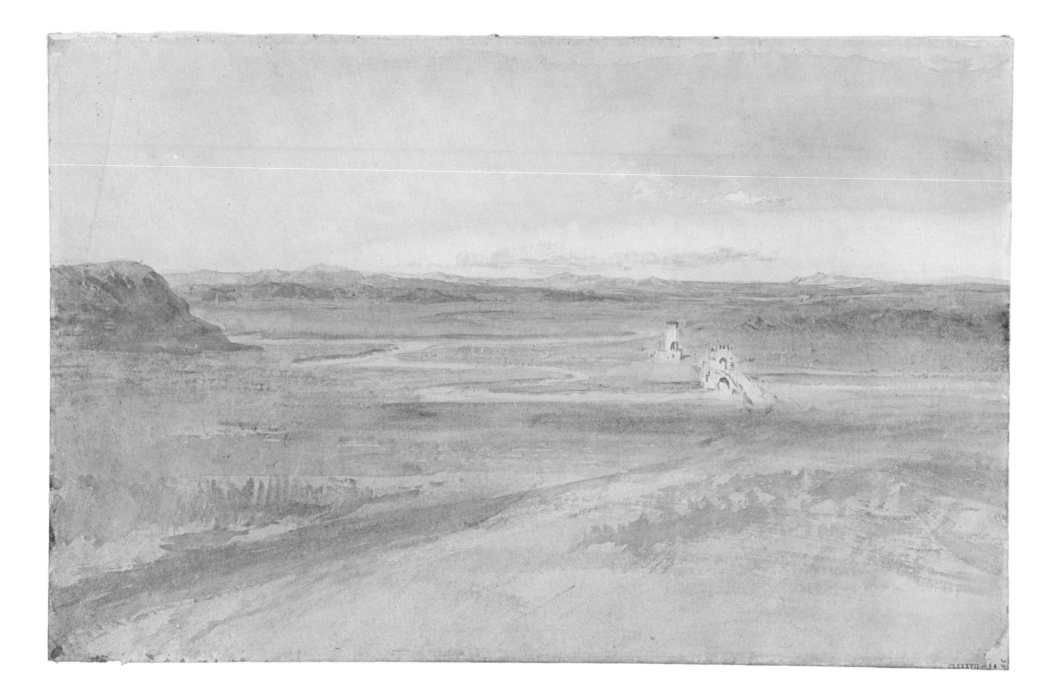

31 The Castel del'Ovo, Naples

1819 Watercolour

257 × 405 mm

CLXXXVII-21 D16109

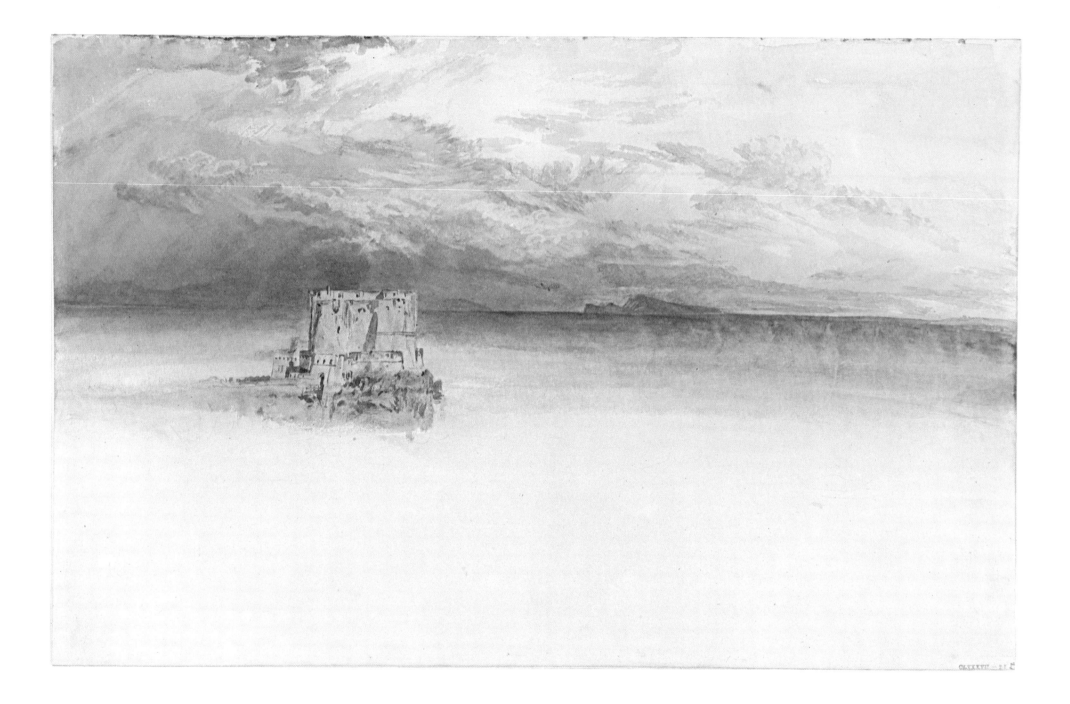

32 Rome from the Vatican

1819 Pencil, watercolour, bodycolour and pen

233 × 371 mm

CLXXXIX-41 D16368

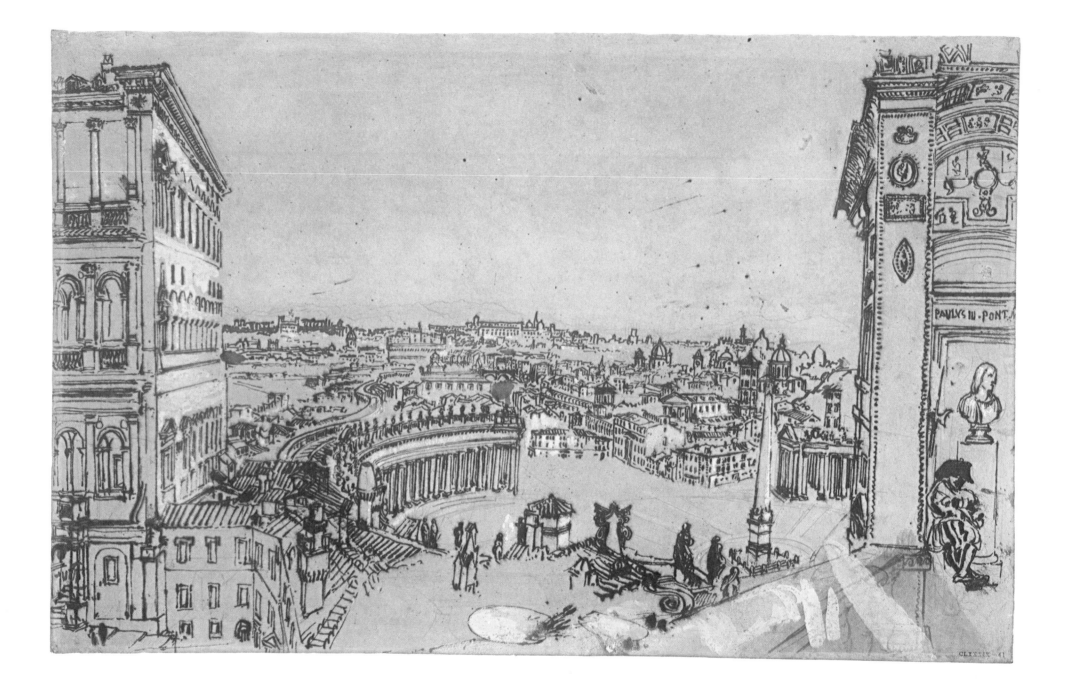

33 Rome from the Baths of Caracalla

1819 Watercolour

228 × 369 mm

CLXXXIX-8 D16334

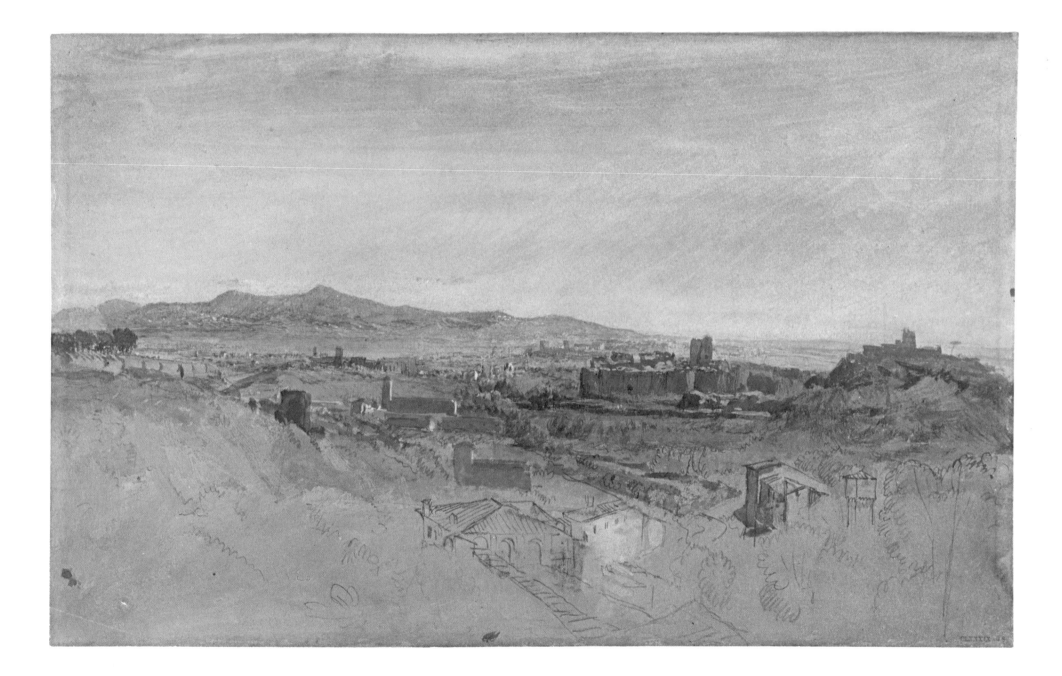

34 More Park

*c.*1823 Watercolour with touches of bodycolour

158 × 221 mm

CCVIII-H D18141

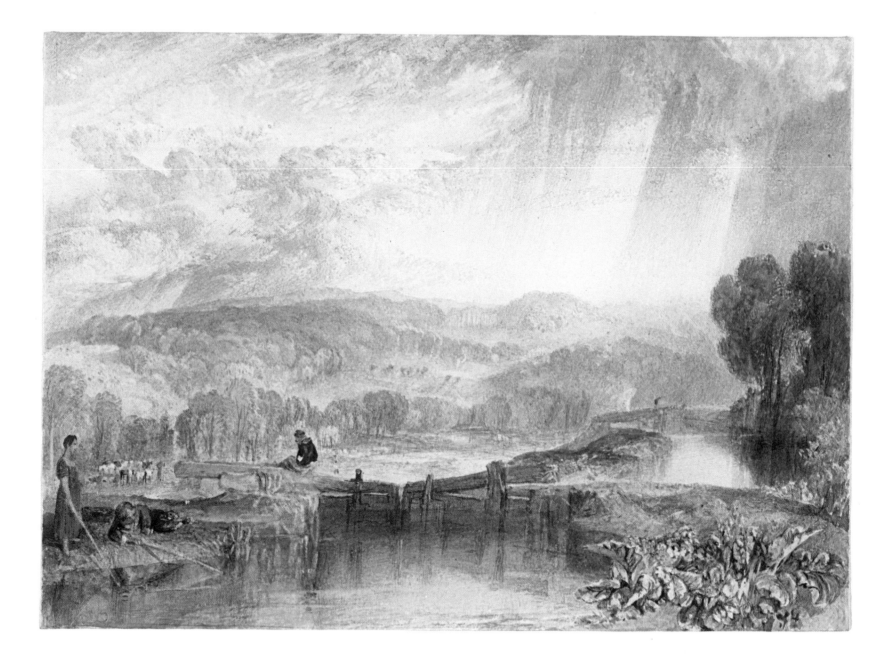

35 Whitby

1824 Watercolour

158 × 225 mm

CCVIII-J D18143

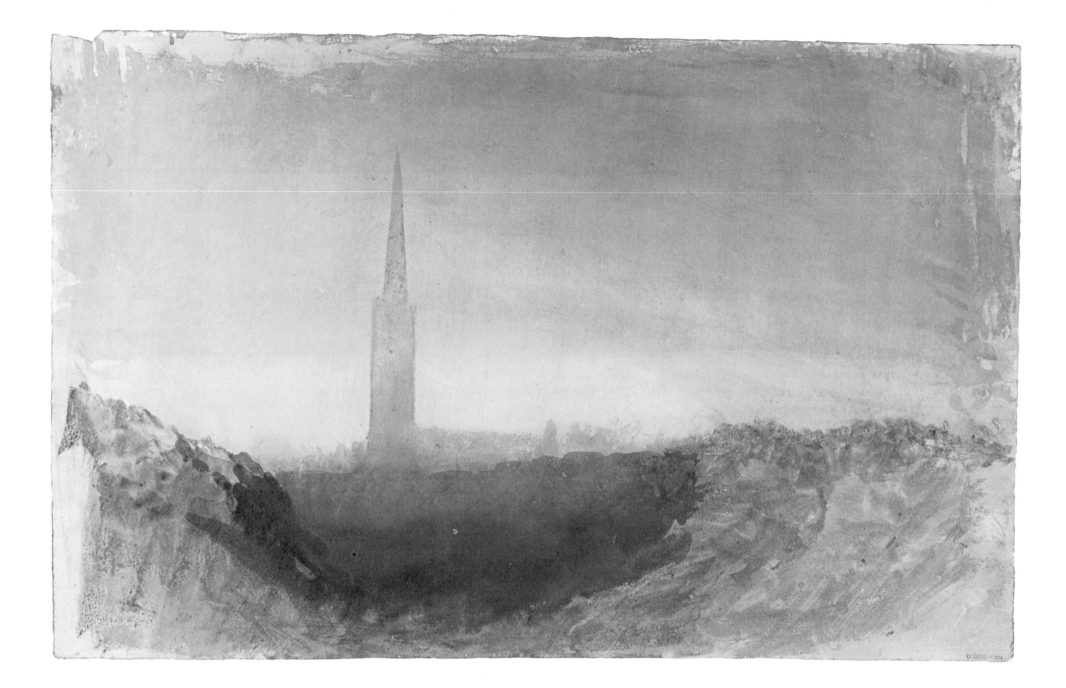

38 The sun setting among dark clouds

*c.*1826 Watercolour

275 × 468 mm

CCCLXIII-306 D25429

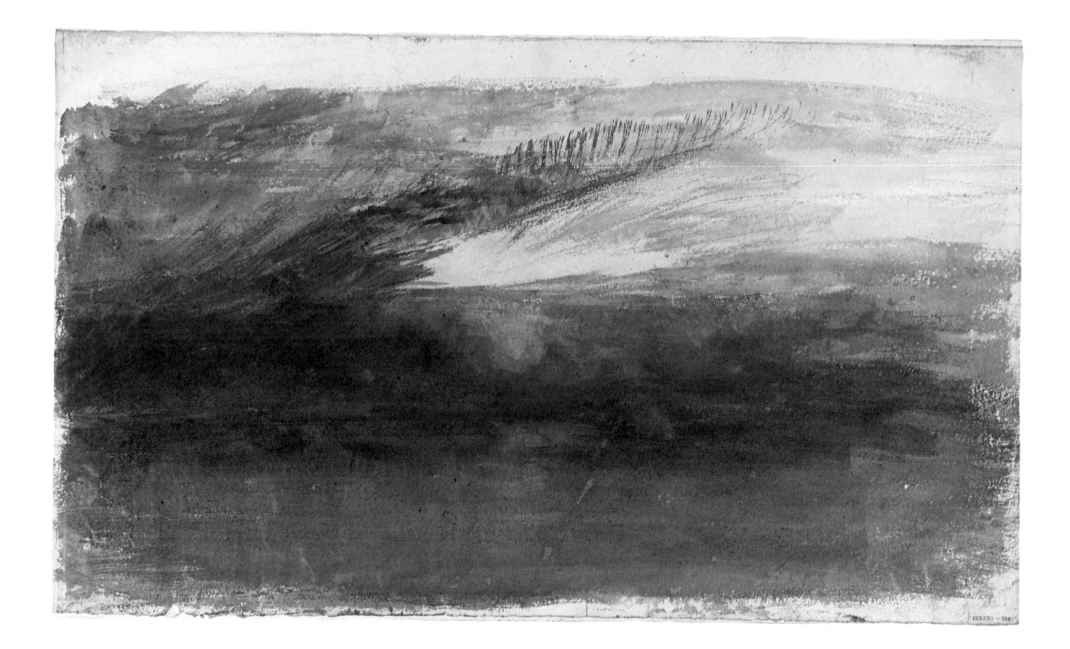

39 Aldeburgh

*c.*1826 Watercolour

279 × 400 mm

N05236

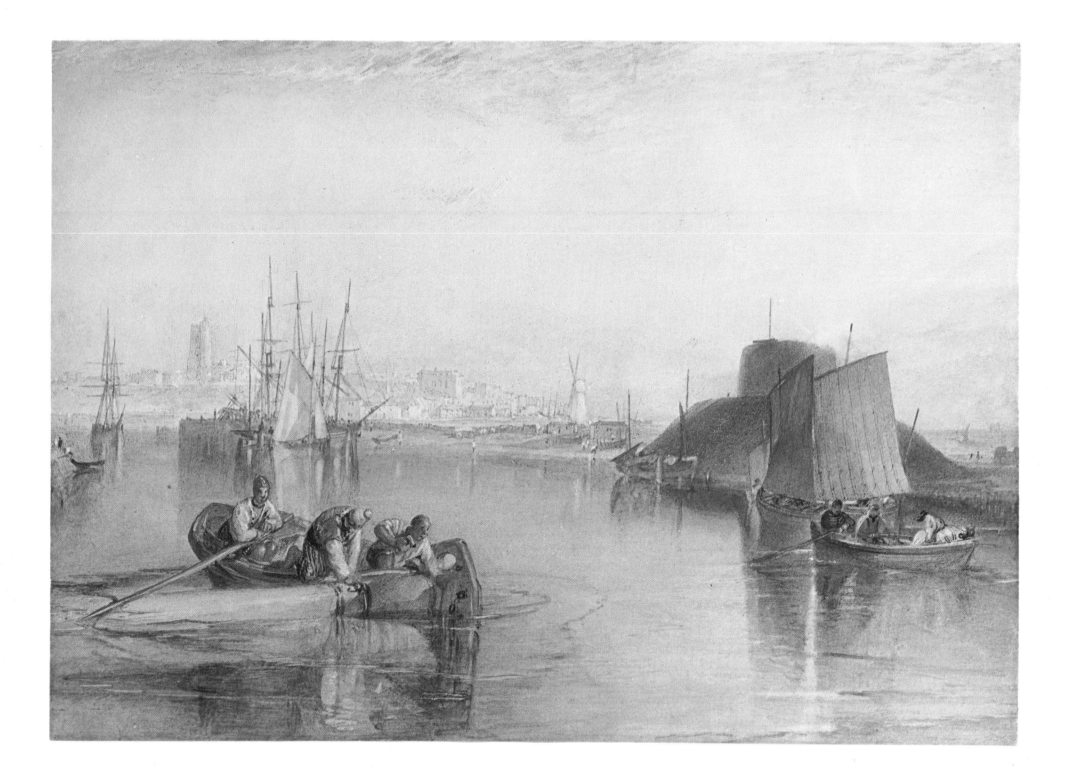

40 Design for a vignette

*c.*1835 Pencil and watercolour

311 × 193 mm

CCLXXX-96 D27613

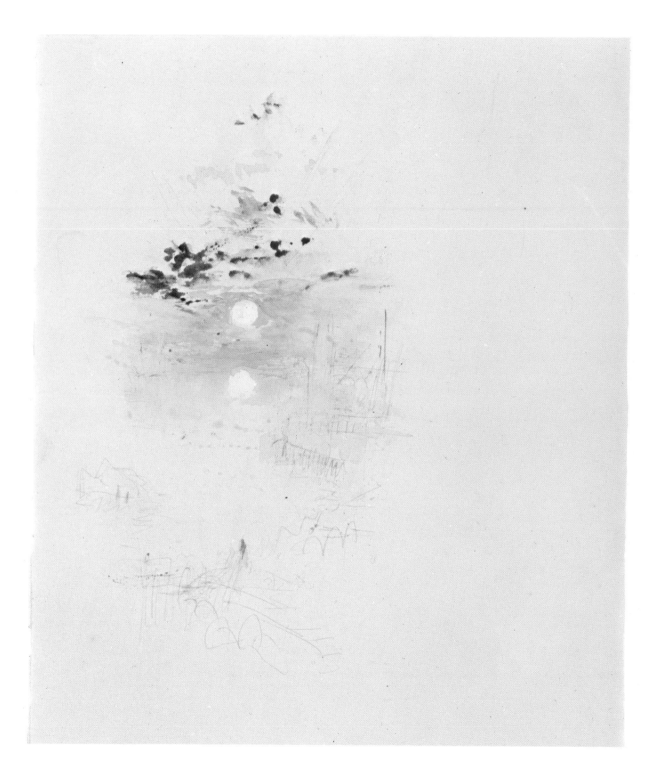

41 Merton College, Oxford

*c.*1830 Watercolour

294 × 432 mm

CCLXIII-349 D25472

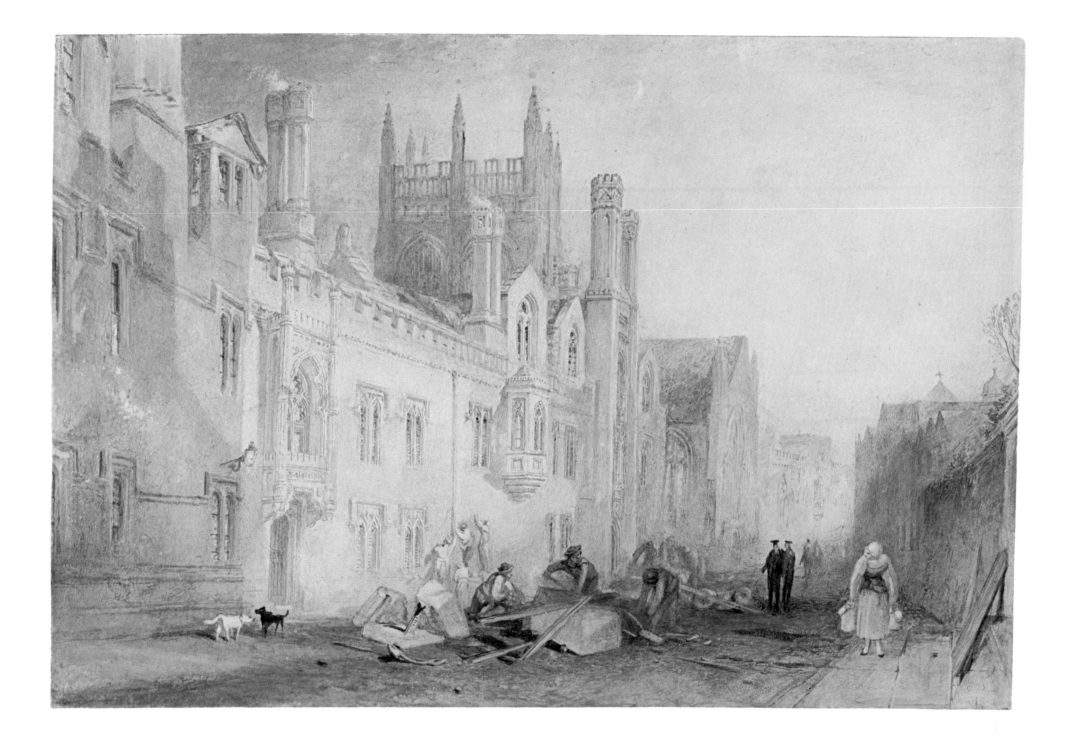

42 Colour Study: Oxford High Street

*c.*1835 Watercolour

376 × 555 mm

CCCLXV-26 D36316

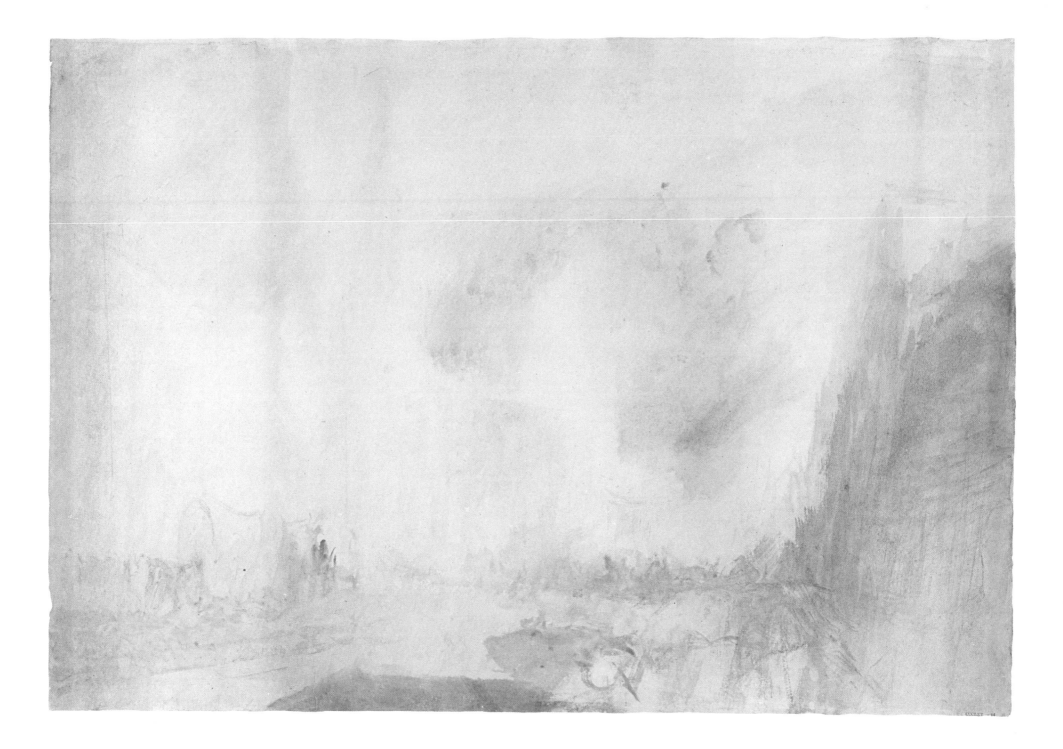

43 Study for 'The Golden Bough'

*c.*1834 Watercolour

306 × 484 mm

CCLXIII-323 D25446

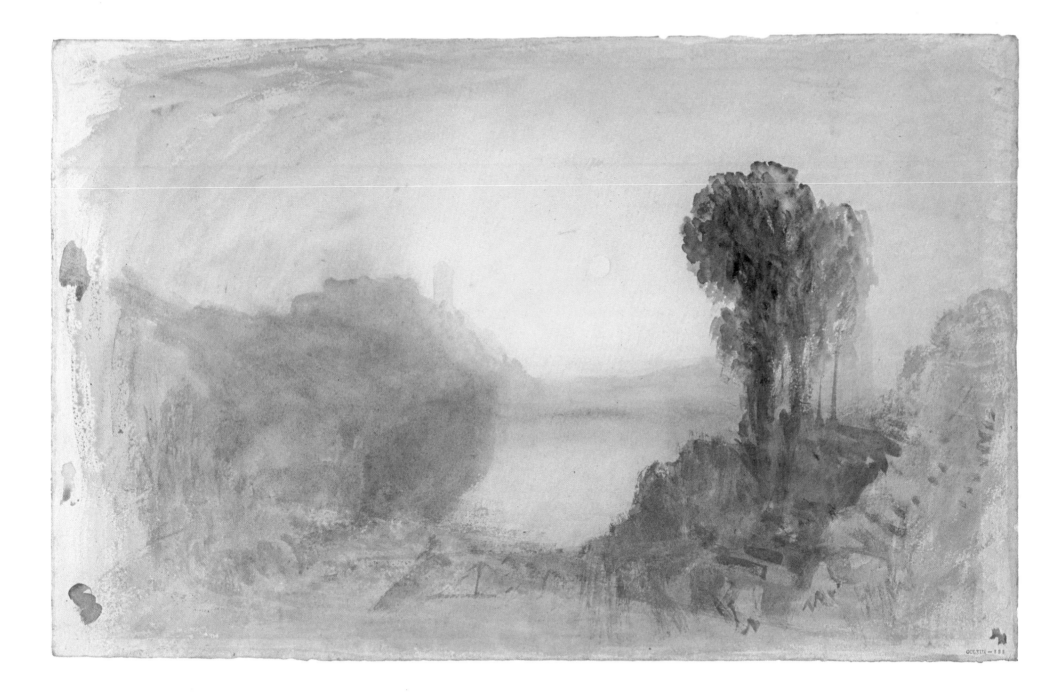

44 East Cowes Castle with crescent moon

*c.*1830 Pen and brown ink with white chalk

on blue paper

139 × 192 mm

CCXXVII(a)-21 D20824

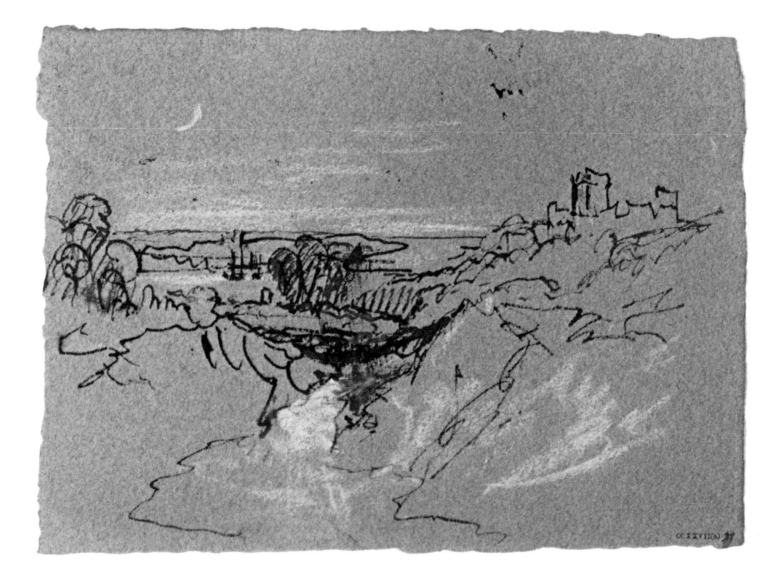

45 Petworth: sunset across the park

*c.*1830 Watercolour and bodycolour on blue paper

140 × 193 mm

CCXLIV-2 D22664

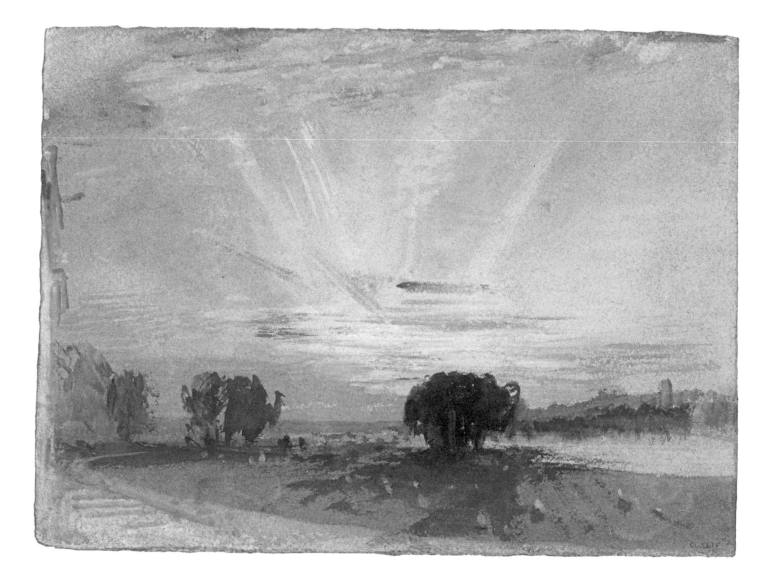

46 A bedroom at Petworth

*c.*1830 Watercolour and bodycolour on blue paper

138 × 189 mm

CCXLIV-17 D22679

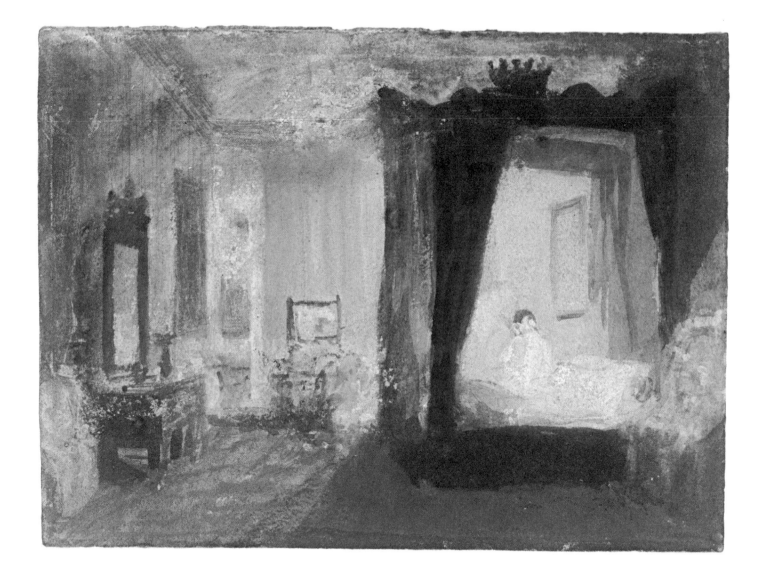

47 Petworth: the red room

*c.*1830 Watercolour and bodycolour on blue paper

140 × 190 mm

CCXLIV-21 D22683

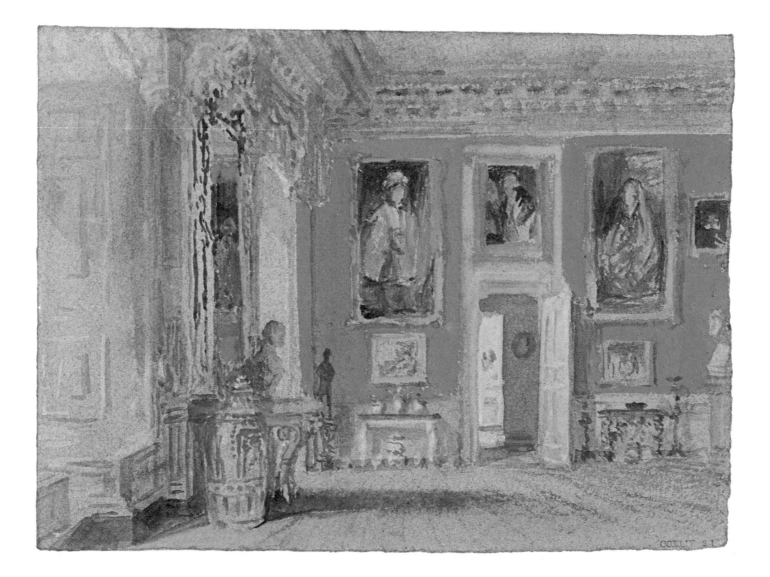

48 Harbour, lighthouse and jetty

*c.*1830 Black and white chalks with red
bodycolour on blue paper
140 × 188 mm
CCXXIV-29 D20319

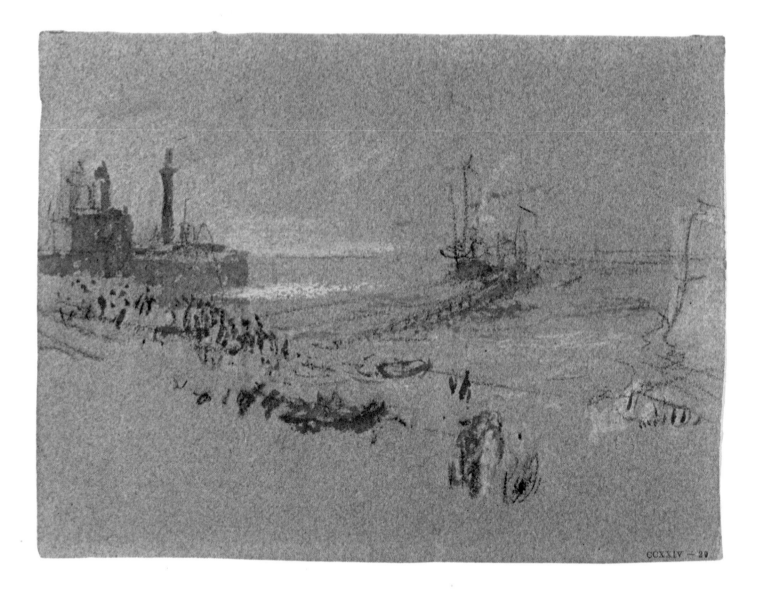

CCXXIV – 29

49 Satan addressing his angels

*c.*1830 Watercolour

186×230 mm

CCLXXX-78 D27595

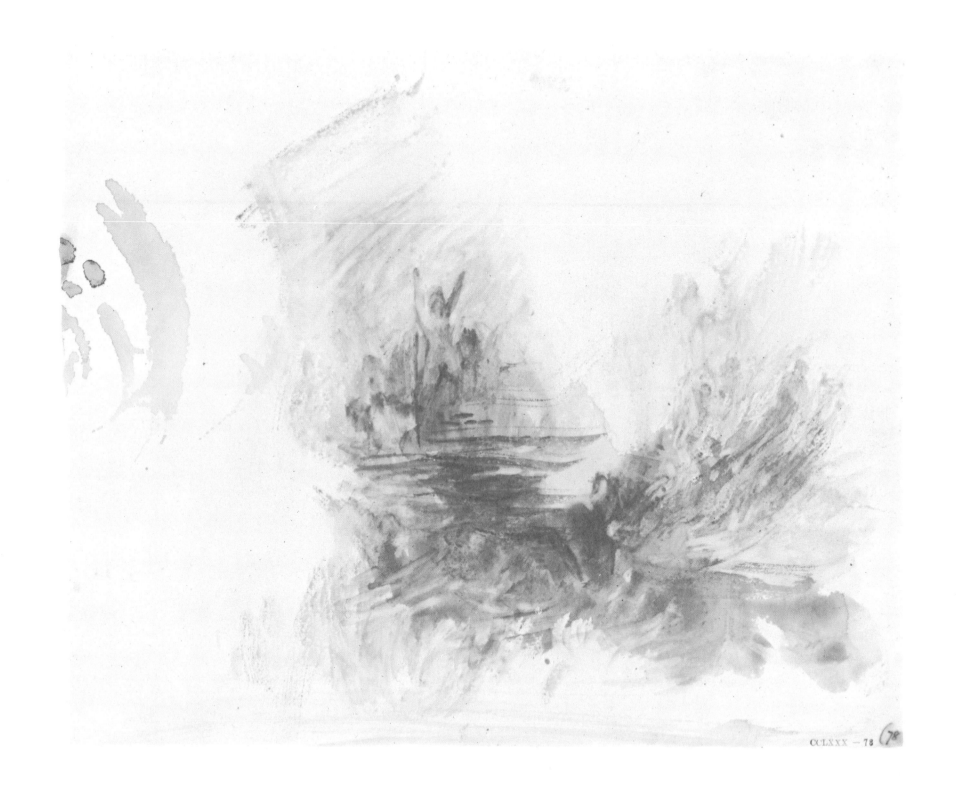

50 Hannibal passing the Alps

*c.*1830 Pencil and watercolour
243 × 305 mm
CCLXXX-149 D27666

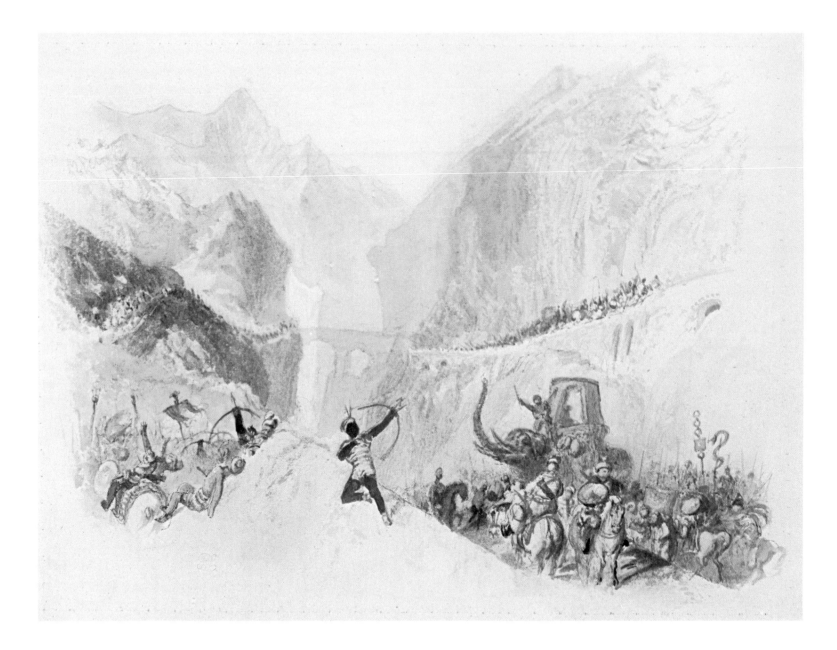

51 Edinburgh Castle: March of the Highlanders

1836 Watercolour

86 × 140 mm

N04953

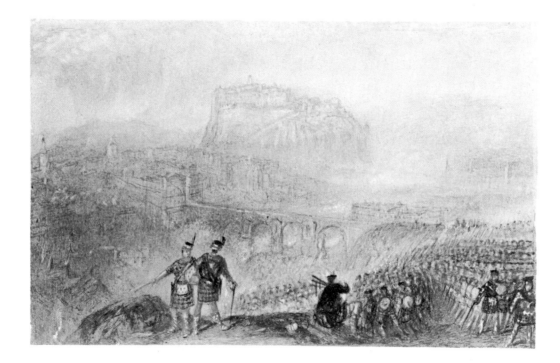

52 Folkestone from the sea

*c.*1830 Watercolour

488 × 684 mm

CCVIII-Y D18158

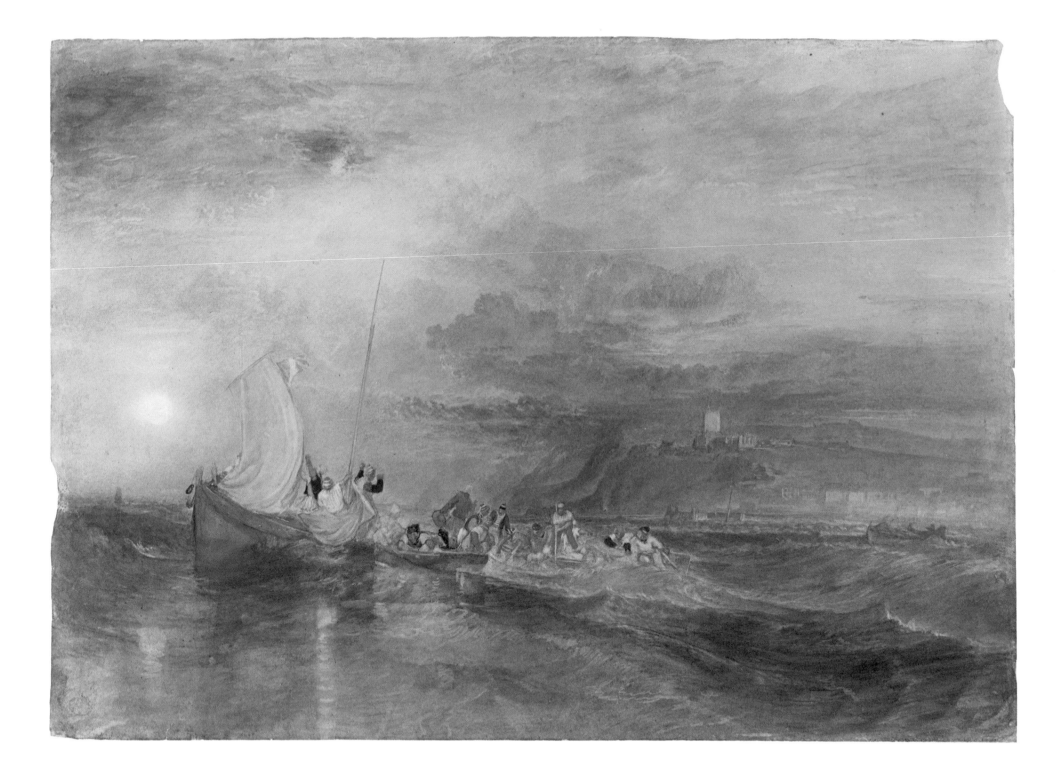

53 Red castle on the Meuse?

*c.*1834 Bodycolour on grey paper

139 × 190 mm

CCXCII-67 D29018

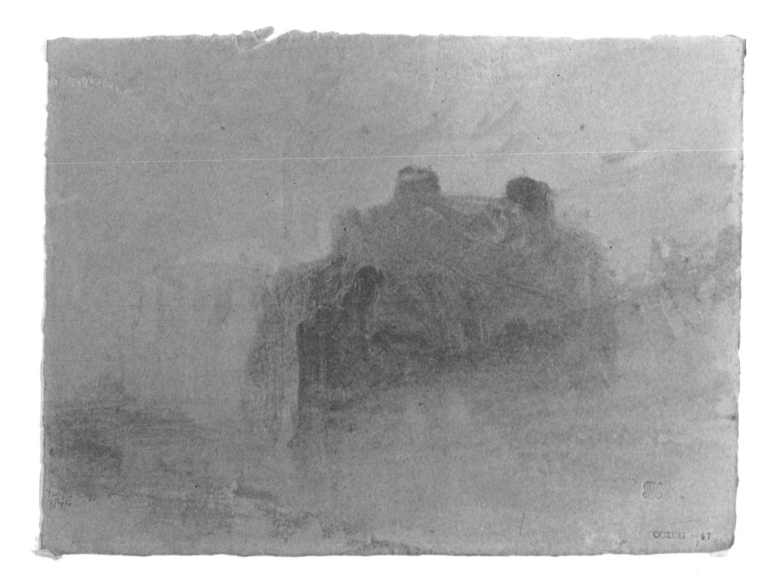

CCXCII – 67

54 Tours; Sunset

c.1832 Watercolour and bodycolour on blue paper

134 × 189 mm

CCLXI-101 D24666

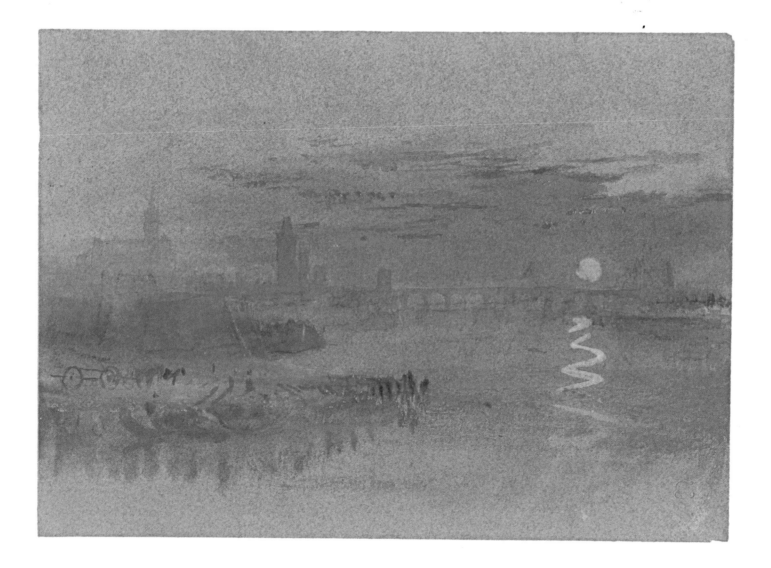

55 Between Quilleboeuf and Villequier

*c.*1832 Watercolour and bodycolour on blue paper

137 × 191 mm

CCLIX-104 D24669

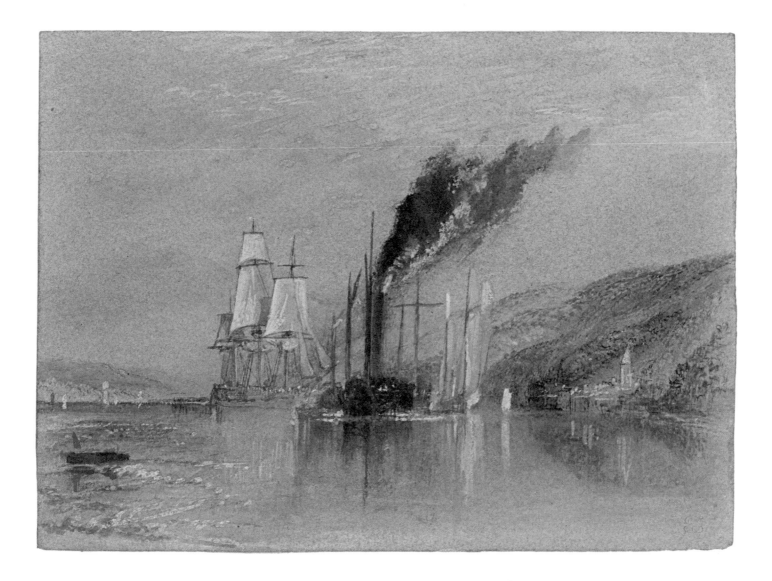

56 Beaugency

*c.*1830 Watercolour and bodycolour on blue paper

124 × 183 mm

CCLIX-96 D24661

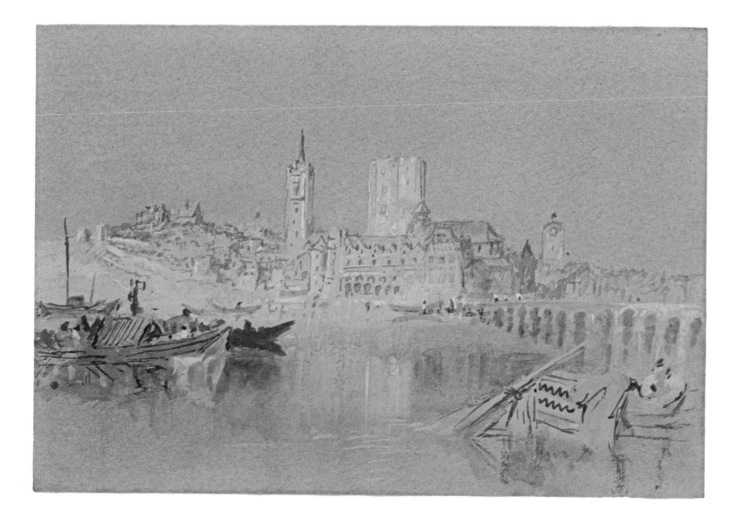

57 Study: the Burning of the
 Houses of Parliament

1834 Watercolour

233 × 325 mm

CCLXXXIII-1 D27846

CCLXXIII – 172

58 The Burning of the Houses of Parliament

1834 Watercolour

302 × 444 mm

CCCLXIV-373 D36235

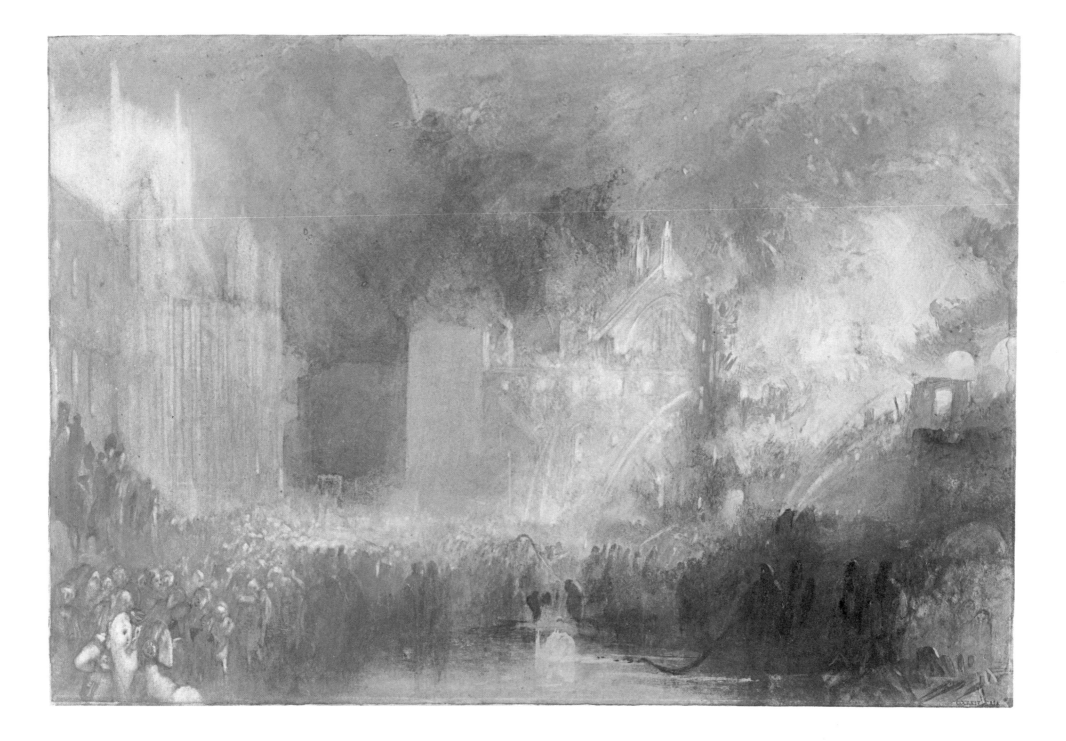

59 Yarmouth

*c.*1840 Watercolour

244 × 368 mm

N05239

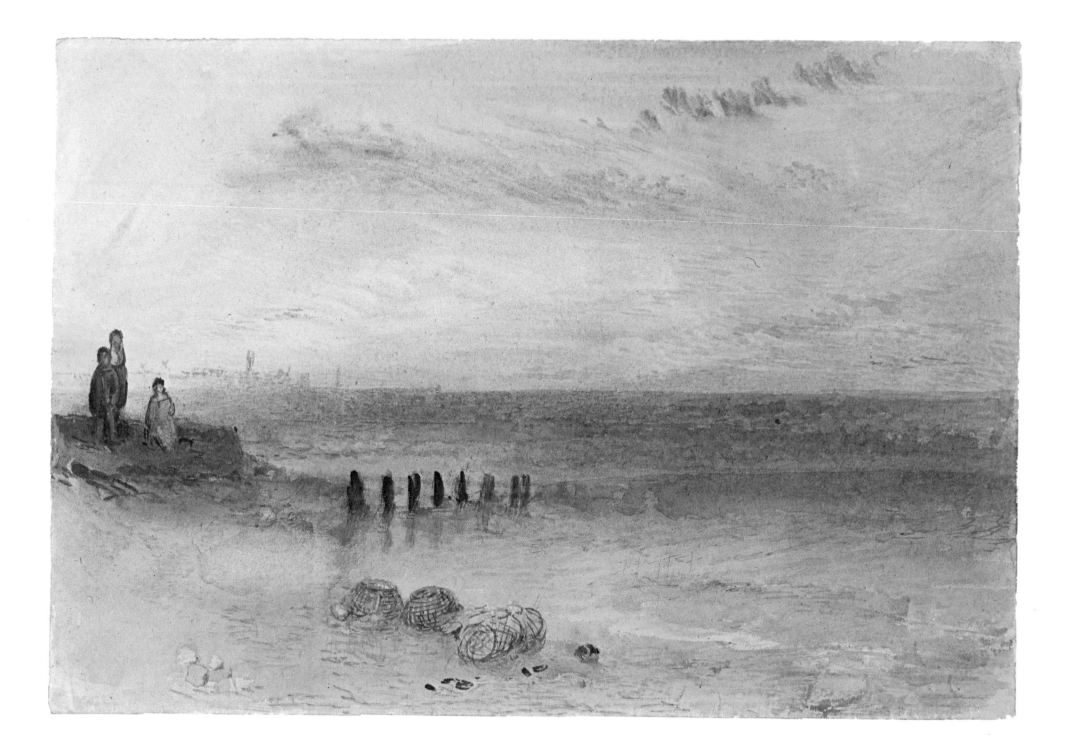

60 Venice: the Salute and Dogana

1840 Pencil, watercolour with touches of
bodycolour and chalk
188 × 279 mm
CCCXVII-16 D32201

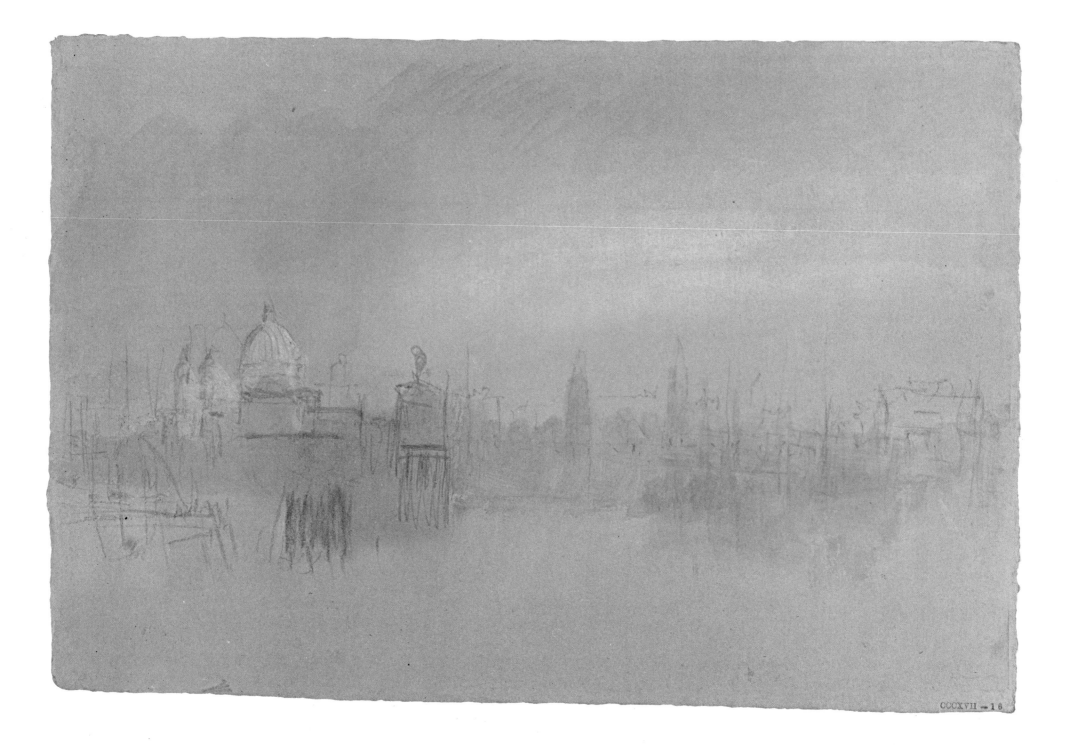

61 Venice: the Salute from the
Calle del Ridotto: night

?1833 Watercolour with touches of
bodycolour and chalk
250 × 307 mm
CCCXVIII-11 D32230

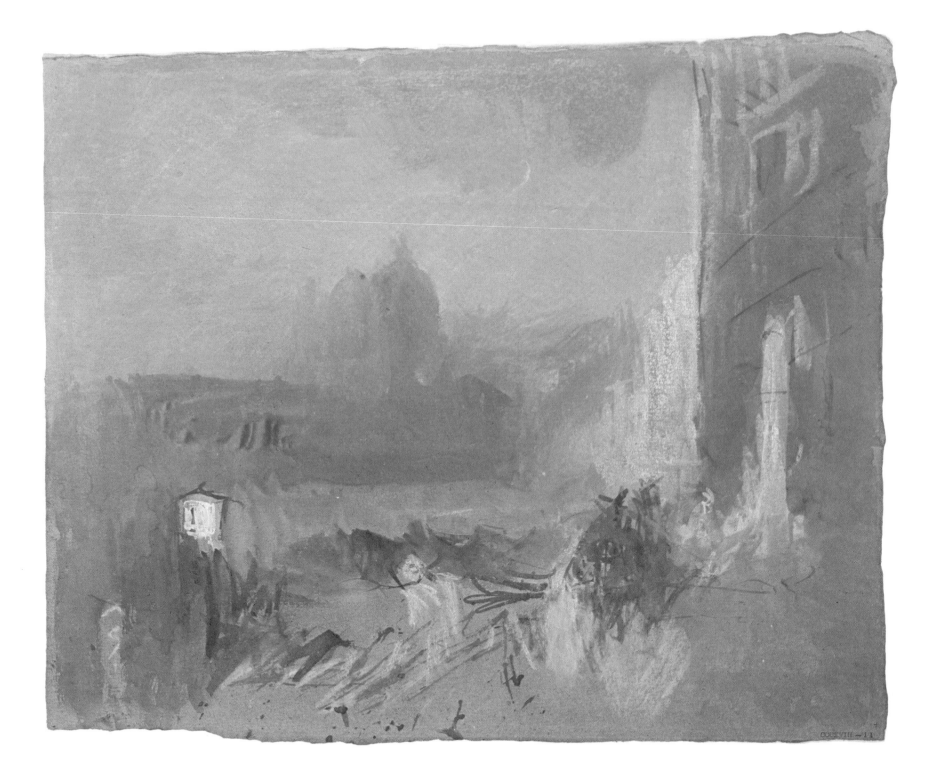

62　Venice: the Casa Grimani and Rio S. Luca

1840　Pencil and watercolour

221 × 324 mm

CCCXV-7　D32123

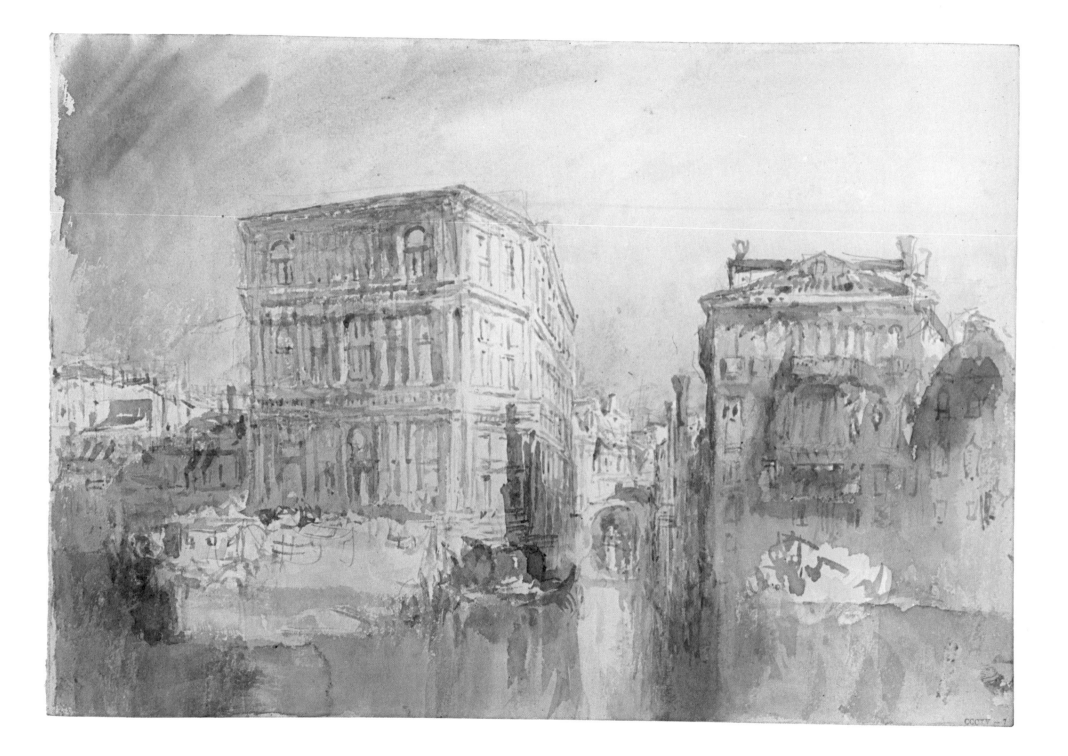

63　Fribourg

1841　Pencil and watercolour
with touches of bodycolour
229×325 mm
CCCXXXV-24　D33564

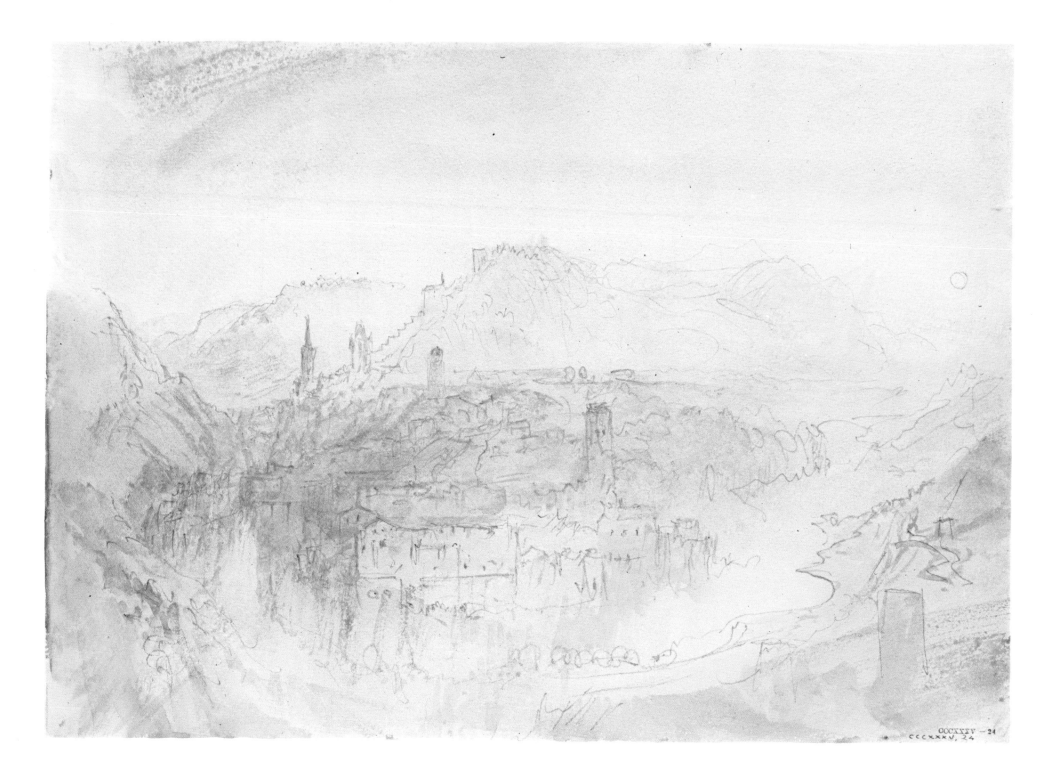

CCCXXXV – 21
CCCXXXV, 24

64 Funeral at Lausanne

1841 Pencil and watercolour

235 × 337 mm

CCCXXXIV-2 D33526

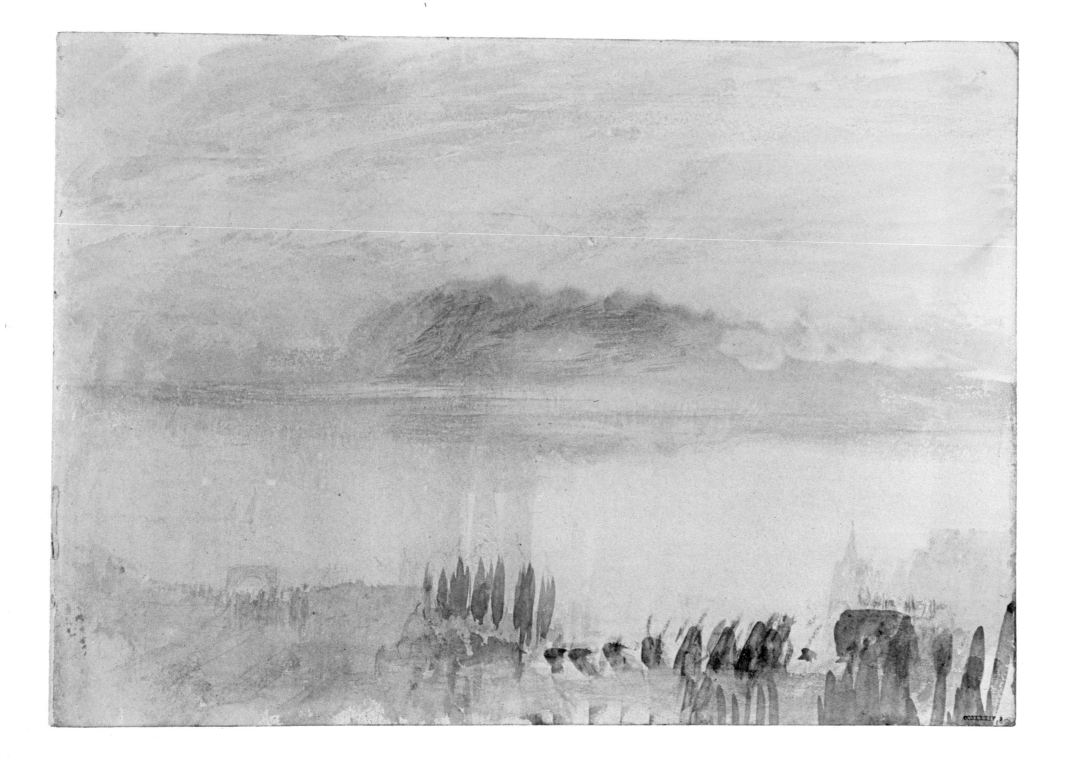

65 Zurich: sample study

1841 Watercolour

241 × 304 mm

CCCLXIV-291 D36147

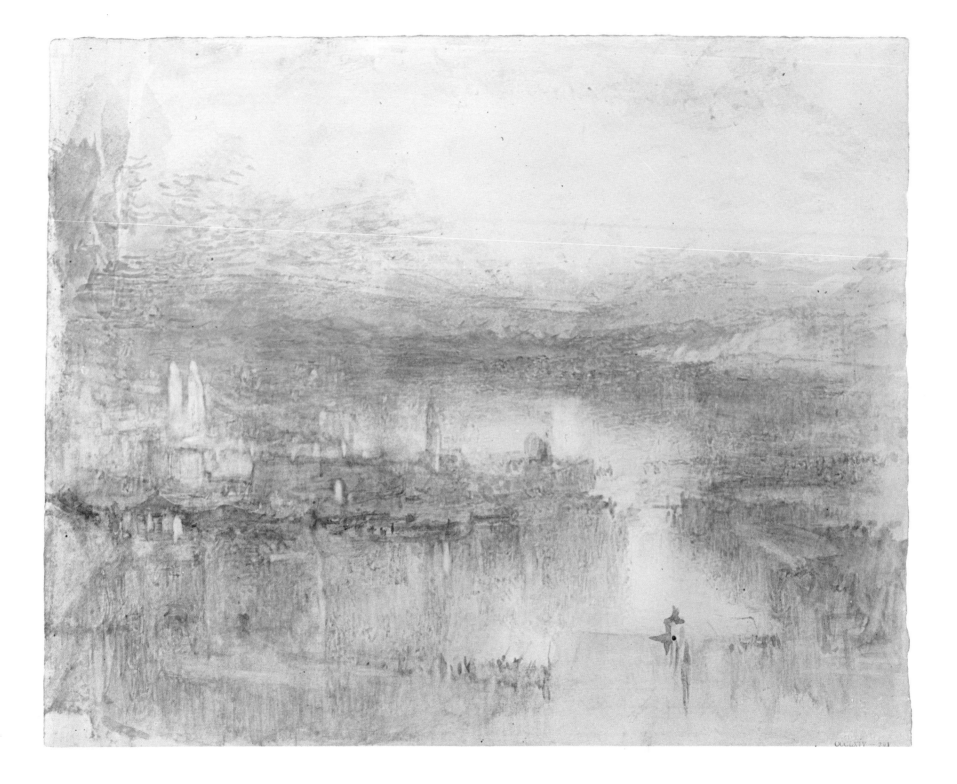

66 Lake Lucerne: sample study

1844 Pencil and watercolour

244 × 303 mm

CCCLXIV-338 D36197

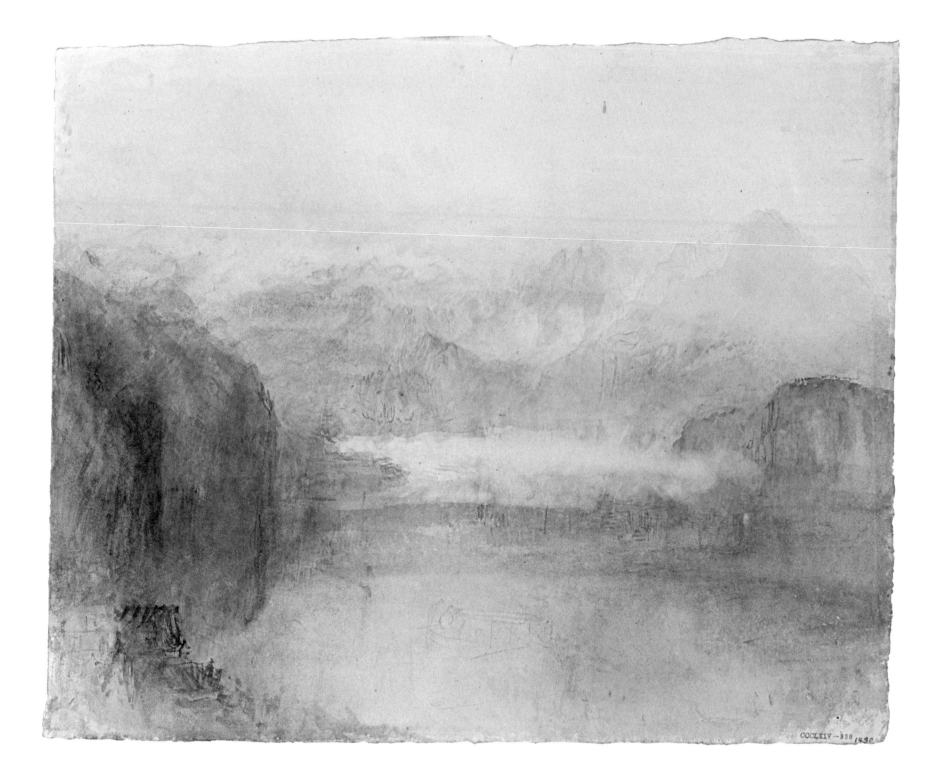

67　Sea-monsters and vessels at sunset

1844　Watercolour with touches of coloured chalk

222 × 325 mm

CCCLIII-21　D35260

32

[148]

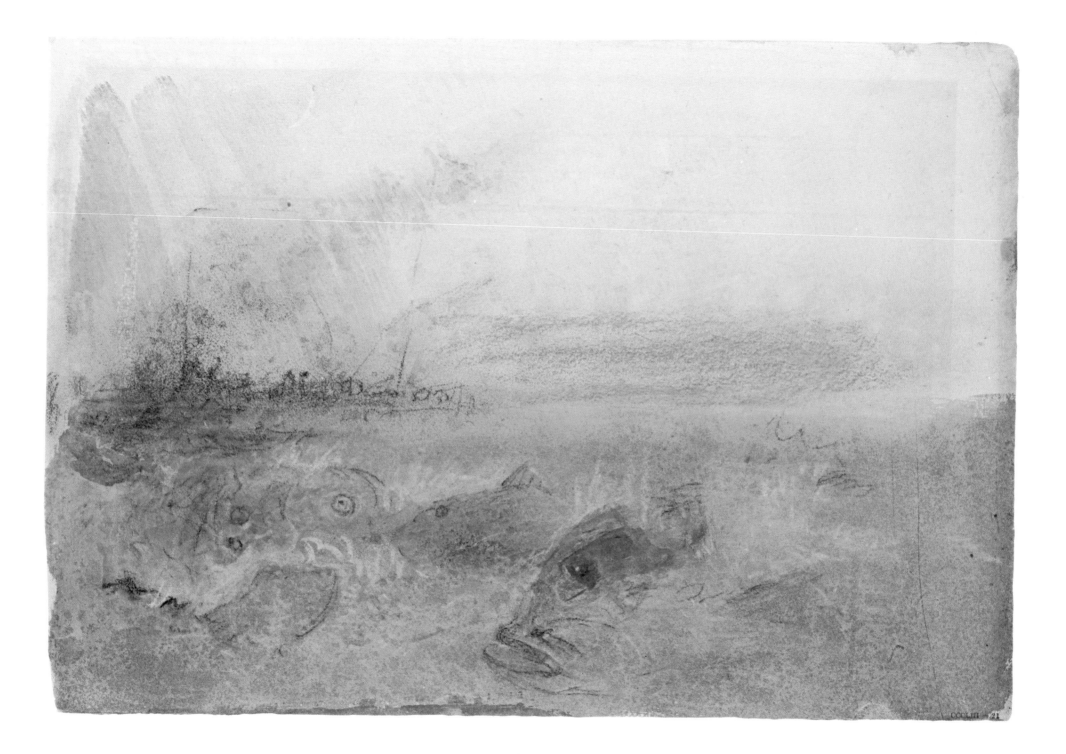